GOODBYE GOD!

WE'RE GOING TO BODIE

GHOST TOWNS OF THE AMERICAN WEST

PHOTOGRAPHS BY Berthold Steinhilber

FOREWORD BY Wim Wenders

INTRODUCTION BY Mario Kaiser

AFTERWORD BY Hans-Michael Koetzle

TRANSLATED FROM THE GERMAN BY Russell Stockman

HARRY N. ABRAMS, INC., PUBLISHERS

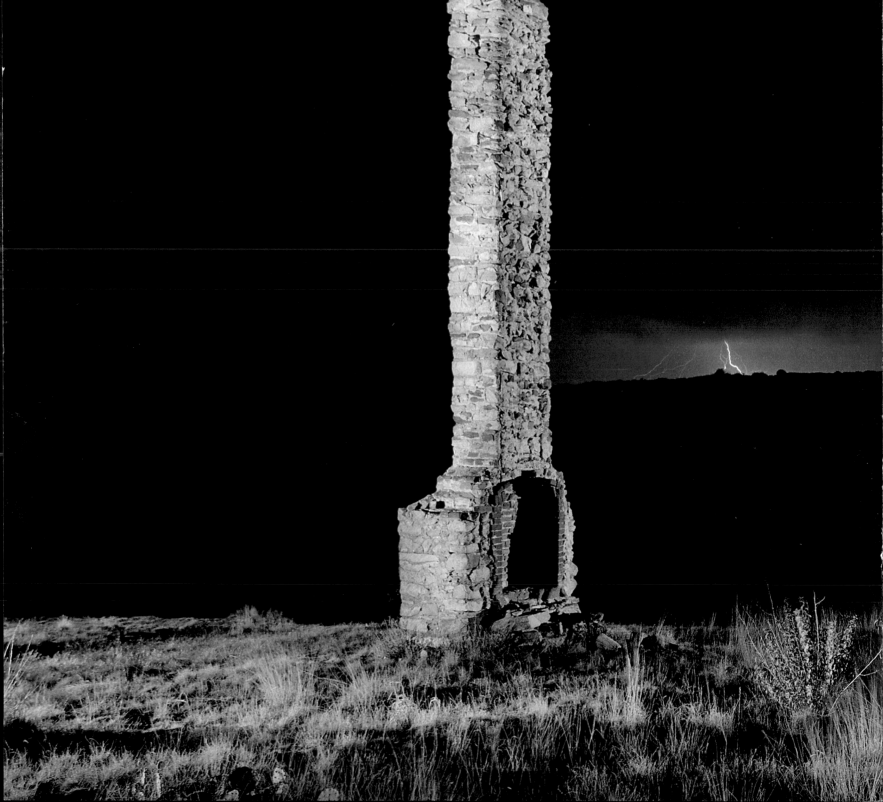

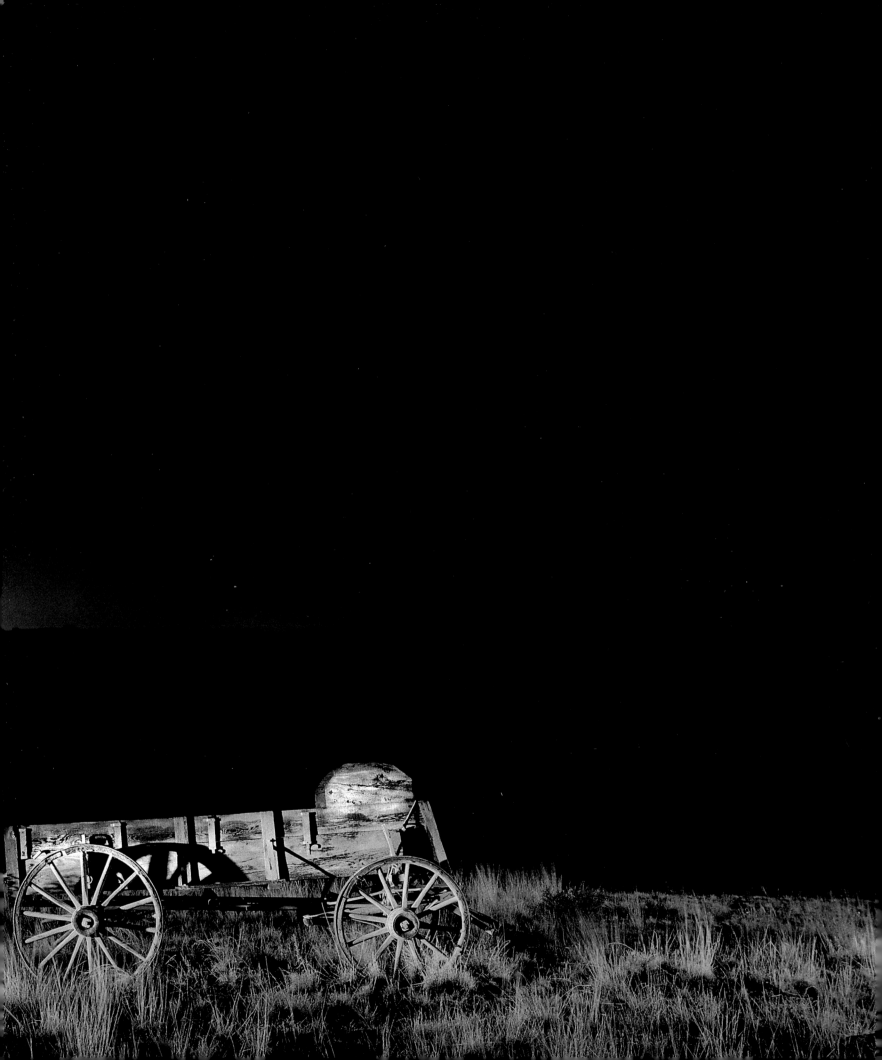

TOWNS AND THEIR GHOSTS

I'D LIKE TO KNOW HOW MANY TIMES I've undertaken a detour simply because a place was identified on the map as a "ghost town." That designation, USUALLY IN PARENTHESES, has a magical attraction for me, AND NOT ONLY FOR ME, almost like a siren song. Even the names of such places are enticing. "Lodi." WASN'T THAT THE NAME OF A CREEDENCE CLEARWATER SONG? "Berlin." WHO WOULD HAVE WANTED TO REBUILD HIS HOMETOWN AMID SUCH DESOLATION? "Gold Point." WISHFUL THINKING. . . .

Car cemeteries have the same melancholy attraction. Each wreck has a story to tell. In the Arizona desert I once stumbled upon a huge burial place for airplanes. Rusted Boeings were lined up side by side the way you'd expect to find broken-down Beetles. Mountains of Cessnas! The ruins of a Caravelle! HOW DID THAT FRENCH ONE GET HERE? I walked around entranced for hours. All these planes had once flown, had hung in the sky for millions of miles! Now they're stuck in the sand like huge boulders. The clouds they once looked down upon today drift over them. Dreams of faraway places, now forever out of reach!

Or decaying automobiles on the side of the road. BETWEEN CACTI OR JOSHUA TREES? Nesting spots for birds. Trees growing out of their windows. At some point that truck rolled over. WAS ANYONE KILLED? At some point someone got tired of changing that flat tire and simply walked away in the heat. A MAN, A WOMAN, A FAMILY? At some point that car ran out of gas. DID THEY GRAB THEIR SUITCASES AND HITCH THE REST OF THE WAY? Bonnie and Clyde. . . .

Do things have some "essence" and can give up their spirit? Aren't they already "dead"? They don't die the way people and animals do, they simply lose their usefulness and are cast aside or abandoned. Shadows of their former selves.

Photographs of old things: They're always portraits of their missing owners, the long-forgotten people who used and carried them. In such pictures the objects seem to take the places of the people they once served.

What about towns that had been abandoned long ago? At some point the last door was slammed shut. DID SOMEONE BOTHER TO

LOCK IT? At some point the water was turned off, the street lamps extinguished, the garbage no longer picked up.

Over there, that was once a school. It says so above the door. WHO WAS THE LAST TEACHER? HOW MANY STUDENTS DID HE, OR SHE, HAVE? AND NOW? A blackboard still hangs on the center wall. CAN YOU MAKE OUT ANY WORDS ON IT? When the kids ran home for the last time, did they know that no one would be going to school here anymore? THE MOST PAINFUL INSIGHT OF GROWING OLD: AT SOME POINT AN EVERYDAY EVENT WILL TAKE PLACE FOR THE VERY LAST TIME. . . .

That building over there was a factory. WHAT KIND OF INDUSTRY COULD THERE HAVE BEEN HERE? WHAT KIND OF ORE WERE THEY DIGGING FOR IN THIS SHAFT? That was a mill, even though the stream has dried up, trickled away like everything else. The church can only be identified from its floor plan. . . . CATHOLIC? PROTESTANT?

Berthold Steinhilber's photographs are inspired and sustained by questions like these, but they don't even remotely attempt to answer them. IN THAT SENSE THEY'RE HIGHLY UNROMANTIC. They become deeply involved in these ghost towns without evoking the ALL TOO OBVIOUS stories of the people who left everything behind there. Paradoxical as it may seem at first glance, these pictures focus not on the towns' past but wholly on their present existence. DO THEY EVEN HAVE ONE?

My knowledge of these places comes from having kicked around in the dust during the heat of the day. DID I PACK ENOUGH WATER? The sun casts deep shadows, AS IN *HIGH NOON*, and makes the derelict buildings seem even more lifeless. When I would look into the rear-view mirror as I drove away at dusk, each place seemed even lonelier and more desolate than when I arrived. "Nothing is emptier than an empty swimming pool," said Philip Marlowe in one of Raymond Chandler's novels. You get the feeling that he had never been to a ghost town. . . .

When you leave such a place behind—BERTHOLD STEINHILBER WILL RECOGNIZE THIS EXPERIENCE—it is with a slight sense of guilt. As if you had brought with you some kind of hope that now fades away. You feel a bit like a deserter. For a little while you were a kind of seismograph, a memory device that would bring it all back to life. There were footsteps again, even voices! ECHOES OF SO MANY OTHER VOICES AND OTHER FOOTSTEPS. . . .

Once, I recall I spent the night in a ghost town. The buildings stood out coal-black against the dark sky. There really was dead silence. Since then, I have never felt so alone, so abandoned by the world. There isn't that kind of darkness in Steinhilber's photographs. The buildings glow, but not the way they do in sunlight, or as they did in the gleam of lamps long since extinguished. Another kind of light exudes here. YES, A LITTLE LIKE X-RAYS.

You get a similar look in black-and-white photography if you shoot with infrared film. But these are color pictures. It's not really even night. You can see the last bit of blue in the sky. OR IS

IT THE FIRST? This is either the last glow of the day just ended or the first promise of a new one. WHY NOT BOTH? It's a period of transition.

In this suspended time, this fairy-tale moment between yesterday and tomorrow, you see these ghost towns in a new light, no longer in connection with the people who once lived and worked here, were born and died here, but solely in their own desolation.

When these places were founded, the streets laid out, their houses, churches, and factories built, people had high hopes. They were making plans, dreaming dreams. None of that can be seen any longer.

Instead, these buildings stand for themselves. They represent these places only as they are now and never were before. NEVER COULD BE. . . . Suddenly they have great dignity. They stand there gazing into the camera like very old people who have never before had their pictures taken, after a lifetime of work and sacrifices. Like them, these objects no longer have anything to do with their former function. Now they're suddenly treasures, as if excavated from the tomb of a pharoah after thousands of years, or raised up from the bottom of the ocean. THESE PLACES LOOK A BIT LIKE ATLANTIS, SLUMBERING FAR BENEATH THE SURFACE OF THE SEA. The typewriter! The washboard! The blade that's still in the razor! The chips still on the gambling table! The price still posted on the gas pump! WHAT DID A GALLON COST AT THAT TIME?

These places, these things, have forgotten us "people," left us behind. The self-satisfaction they now display, with no tinge of sadness, no longing—they've never been seen like this before. When could anyone have captured this? At the beginning of photography, of course, in the first photographs by Niépce, Fox Talbot, Nadar. And in daguerreotypes to be sure. But with modern methods?

Perhaps we have simply forgotten that patience can also be seen as a modern method. And that photography can still do everything it managed to do back then, that it can still capture places in a way they've never been captured before.

As an afterthought to these images, I am left with the feeling of having seen pictures from another planet, a little like those from the fabulous probe that landed on Mars and sent us images of a reality that exists wholly without human beings, so obviously and frighteningly independent of us. I feel like some confidant given a peek of the secret existence of places and things that no longer need us, in a time zone that can't be registered by our clocks, in a country that lies in the western United States, to be sure, but still has no president. OR IS IT THE YOUNG LINCOLN? OR ALREADY THE FIRST ROOSEVELT?

Berthold Steinhilber hasn't photographed ghost towns. Instead, he has revealed the spirits of these places. Places and objects are tenacious. We're the ones who are convinced they could not exist without us. But they're not so quick to surrender their spirit.

WIM WENDERS

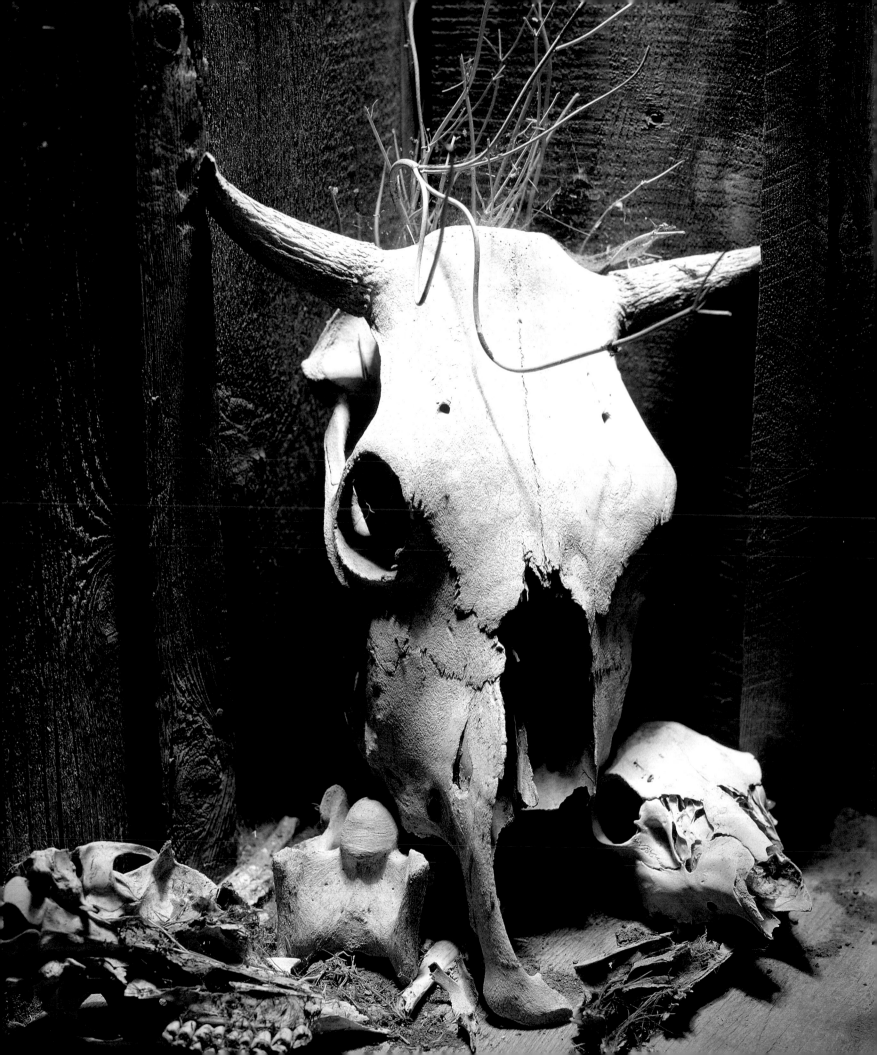

"LET'S GET OUT OF HERE. WE'LL FIND LUCK SOMEPLACE ELSE."

GO WEST! THERE'S GOLD OUT THERE! SILVER! And so, in the middle of the nineteenth century, the great Gold Rush began. Hundreds of mining camps sprang up out of the ground in the mountains and deserts of the West, wherever there was rumored to be gold and silver. From California to Nevada and Colorado, from New Mexico and Arizona to Utah, men hollowed out the earth in feverish dreams of wealth. But their dreams were bigger than the deposits of gold, and by the beginning of the twentieth century the excitement was essentially over. The mine workers deserted their camps, abandoning empty buildings and mine shafts, leaving ghost towns that were quickly forgotten. None of these deserted sites is more than 150 years old, and at most they were inhabited for only a century. A tendency to pick up and move, to abandon house and home and start over somewhere else, was common. Traditions and ways of life were not deep-rooted. It was their way: use it up, then forget it. Herb Robbins, who has been exploring the ghost towns of the American West for years, found that a shame. While visiting these relics of the Gold Rush he had the idea of keeping at least one of

these towns from disappearing entirely. In the late 1970s he bought a piece of property in Gold Point. He had found his calling.

He was impressed that this spot in the Nevada desert had managed to survive through natural catastrophes, the closing of the mines, the exodus of the workers. Often it was touch and go; for a time he was the town's sole remaining resident. But he stuck it out. Today Gold Point has a population of six. But no one is more attached to the place than Robbins. He has always looked up to the pioneers of the Old West—amazed by what they suffered and what they accomplished.

Gold Street is only a strip of gravel. It is as wide as a boulevard and curves through town, lined by unpainted wooden shacks with sagging roofs. Affixed to some of their gables are crosses made of picks and rusty shovels. Their windows are opaque with dust, and inside bare mattresses lie on the beds. At the filling station across the street the price of gas still reads $35^{1}/_{2}$¢ a gallon. An American flag flutters above the abandoned post office. Somewhere the wind is banging a door, making a sound like the clapping of an invisible hand.

Herb Robbins heads over to the Hornsilver Townsite & Telephone Company building, the lettering of its name still bright. At Second Avenue he passes the skeleton of a truck. It stands there as though parked an eternity ago and forgotten, robbed of its motor and wheels. The door on the driver's side hangs like a broken wing from one hinge. Around the corner, on Main Street, the Gold Dust Saloon casts its shadow behind barbed wire and thornbushes. Gold letters still gleam on its facade. The locked door carries the number "22," a reminder of the time when Gold Point had street numbers. The windows are curtained. A decaying stool adorns the veranda.

Behind the buildings, beneath a sky as blue as the center of a gas flame, the old winching towers rise up out of the desert. Some seven hundred men once raced to this mine, and to the town then still called Hornsilver. They found silver, sure enough, but it was not enough to make seven hundred dreams come true, so most of them left as precipitously as they had come. Their boomtown became only a stage set that gradually took on the color of the desert.

The spot where all the excitement began is up on the hill behind the town. The sign on the Great Western Mine is no longer legible, the letters long since reduced to weathered splinters. The winching tower still stands above the blocked shaft, a skeletal construction of timbers rising up to a point. They enclose a huge, rusted ore hopper, through whose mouth the wind howls. Above the hopper the cable hangs slack around the winch. Two rungs are missing from the ladder leading to the top.

A few steps farther on stands a corrugated-metal structure the color of zinc. Shafts of light from holes in the roof illuminate the gloom inside, and hundreds of bullet holes make a pattern of bright dots in the walls. The space is empty. Bolts as thick as a man's arm jut up out of the foundation where machines used to be anchored. Here were the ore mines, where the ore was reduced to grains, and the vats in which it was eaten by chemicals. Up under the roof you can make out the olive-green eyes of an owl. The structure begins to move. Sways, creaks, shudders as the wind plays with it.

Outside stand the rusting cyanide tanks. The huge cylinders are empty, and their stirring poles are stilled. Yet they give you some idea of the quantities of poison required to separate gold from the ore. A tongue of Mars-red earth blankets the slope, as though blood had seeped into the ground. Few bushes grow in this soil, their branches the same reddish brown as if they too were rusting.

There are fleeting moments when the town revives. When you see something silver glistening in the sand, and you kneel down and dislodge the works of a pocket watch, patented 1908. Then you look over at the winching tower of the Dunfee Mine sticking up out of the desert like the tip of some subterranean machine, steely and black, and you see that the wheel at the top isn't moving, that there's no longer any cable around the winch, and that there are no bulbs in its lights. Gold Point once again becomes a ghost town.

May 21, 1905, was the day it all began. Howard Russell and William Kavanaugh stumbled upon an exposed outcropping of quartz in the place that would one day be known as Gold Point.

It contained silver valued at $6 to $8, and it inspired the two men to search further. After digging some one hundred feet down they hit a vein from which they ultimately managed to recover silver at a rate of $91 per ton of ore. They erected a winching tower and installed an elevator as strong as fifteen horses. Forty men worked in the shaft that was now called the Great Western Mine. At that point the area the men were digging in was called Lime Point, named for its surface limestone. The news of a silver strike quickly spread, and men from all over set out for the mine. By the spring of 1908 the camp had a name: Hornsilver. The madness had begun.

At about that time, in his makeshift office on Horn Street, the reporter for the *Hornsilver Herald* rolled a sheet of paper into his typewriter and wrote: "The big thing has happened." At the Great Western Mine, Russell and his partner had struck a silver vein worth nearly $135 per ton of ore. They were now digging a good two hundred feet below the surface. The *Herald* put out its first issue—four pages of celebratory prose—on May 9, 1908. It reported that the Hornsilver Mining Company was offering fifty thousand shares at 15¢ a share. On the next page the Hornsilver Townsite Company praised its house lots and exhorted readers: "Secure yourself a place in the camp of destiny."

Bids on their parcels reached as high as $1,000, and in no time they were all sold. Hornsilver then stretched for two miles from east to west and a mile and a half from north to south. Some 125 buildings and tents had been put up in the town, more than double the number from only two weeks before. Scarcely a day went by

without the opening of a new business. Matt Maher & Co. stood ready to transport ore, wood, and hay with some sixty horses and mules. The Barnes brothers had opened the General Merchandise Store. The Exploration Mercantile Co. was carrying a full line of mining tools. Mrs. Sarah Woods had expanded the Hornsilver Restaurant into a hotel.

Men, horses, and wagons thronged the dusty streets. Buildings shot up on every corner, and day and night the air was filled with the sound of hammering. W. M. Gotwaldt, a reporter for the *Goldfield News*, visited Hornsilver and wrote: "Toward noon a wagon loaded with wood stopped in front of an empty lot. It was followed by a second filled with kitchen equipment and foodstuffs. . . . When we returned a few hours later, after a tour of the mines, there was a hotel standing at that very spot, and they were serving dinner in the dining room."

The town continued to grow. A post office was opened to handle its mail. The Kernek Auto Rental Co. would drive you to Goldfield, thirty miles away, for $7.50. A chamber of commerce was formed. Hornsilver now had a bookstore, a barbershop, a volunteer fire department, and a hospital with a single patient. The Union Bakery advertised "the best bread around, baked fresh daily and promptly delivered." All that was missing were a bank and a church. The latter would never be built, for the town looked to the earth, not to heaven. More and more shifts were lowered into the mines, where workers extended the shafts deeper and deeper. A labyrinth of some fifty tunnels lay under the Hornsilver area. The various mines and shafts bore names like the titles of novels:

"Redemption," "Silver King," "Nevada Empress." The *Herald* told their stories in capital letters. "The present in Hornsilver is good," it read. "The future can take care of itself."

The town was intoxicated, blinded by the gold that was being found almost as often as silver and by a faith in the salvation it would bring: "Ore, ore, ore everywhere, in every fissure and crevice," the *Herald* proclaimed. Yet Hornsilver was an innocent place compared to other mining towns, like California's wild Bodie, where it was said that the gravedigger never had a day off. On May 23, 1908, the newspaper reported Hornsilver's first arrest. "Deputy sheriff M. J. Spaulding found his first victim this week," the paper related. "The unruly citizen had poured himself full of whiskey and had to be arrested. In the absence of a jail, Mr. Spaulding chained the citizen to the rear wheel of a large wagon with handcuffs, where the man stayed until he was in a position to think more clearly."

Robbins keeps his archive in his living room. Yellowed newspapers, a heavy photo album, framed black-and-white pictures. One such picture shows a group of mine workers crowded around three cars. Some are smiling, others staring stone-faced into the camera. "April 24, 1908," someone has written on the back. There are other pictures of ore mines over on the hill. A cloud of steam rises from the roof, and inside the round press is turning. Under the electric lights a conveyor belt runs between ducts and vents. Two workmen are bent over the leaching vat.

One morning Robbins took me down into one of the mines. We drove toward Mount Dunfee, then up a winding road to where a corrugated-metal shack stands on a hill. It's the old smithy. Robbins bent down over an iron hatch in the floor and lifted it up. There was a hole in the ground, yawning between his legs: the entrance to the Spindlekop Shaft. We fastened lamps to our belts and climbed down a series of wooden ladders, moving slowly, gingerly testing each rung. Some were broken, and we would have to feel for the next one. The daylight grew dimmer overhead, and soon we were completely dependent on the light of our lamps.

The ladders ended some two hundred feet down. We shined our lights into a tunnel, a low gallery leading toward the west. Stooped over, we followed the cones of light from our lamps. Behind us the corridor again closed in darkness. In time we came to a room from which a steep shaft led still deeper into the earth. Robbins kicked a few chunks of rock over the edge and we could hear them echo far below. We climbed down a wooden ladder. Above our heads hung the pipes that once brought water and compressed air down to the depths. Then the shaft became so narrow that we had to turn ourselves around and climb down the rungs backwards. We could taste the dust in our mouths.

At the foot of the ladder we entered a dome-shaped vault. We were more than four hundred feet underground. Robbins slipped off his backpack. An empty, rusty ore cart stood on the tracks in front of us. I pushed it forward with some effort and was amazed that mine workers were able to make it budge when it was filled with ore. Day after day they would slave down here for eight hours, stooped over, soaked with sweat, their mouths full of dust and their ears ringing from the noise of the air hammers they used to drill

the blast holes. They would fill these holes with dynamite, light the fuse, and then run. Terrified, they listened as the timbers groaned above their heads. When they saw rats racing away, the men knew that the gallery was about to collapse. It was a terrible way to get rich. They ruined their bodies and risked their lives. In their underground struggle they had but few helpers: the mules they harnessed in front of the ore carts. They could depend on the beasts to pull the carts through the galleries, until the dust clogged their lungs. Mules that went down into the mines never saw the light of day again. They lived and died at the workers' sides. The men treated them well—they knew that their own lives depended on them. The owners of the mines worried more about the animals, for if a mule died they were forced to train a new one for life underground; if they lost a worker, they simply hired another.

Robbins followed the tracks deeper into the tunnel. We climbed over boulders that had fallen from the ceiling, and ducked under sagging wooden beams. Then we turned into a side gallery almost completely blocked with rubble. We had to crawl through the opening on our hands and knees, and we soon came to the end. A twisted ore cart lay upside down next to the tracks. We turned around and could see how the gallery twists and turns. This is the "drift," the path along which the miners worked the vein. They had drilled a series of holes in the wall but never proceeded to fill them with dynamite, and the fuses still lay in the dust on the floor. Robbins ran two fingers across the wall, which was smooth and bluish—a sign of silver. The dust trickled down from his fingertips. There is gold and silver down there to this day but it costs too much to get it out.

The air in the tunnel smelled stale. It was altogether motionless but dry and cool, unlike that of the even deeper shafts. The deeper you go the warmer it gets; at a little over two thousand feet below the surface, the air in mine tunnels is already heated to roughly 77°F by the surrounding rock. Owing to poor ventilation and heat from machinery, the temperature could easily have risen to above 120°F. Tools could become so hot that the men could only touch them with gloves on. They worked until all the strength was drained from their bodies along with their sweat. At the end of each shift the miners, flushed and exhausted, would laboriously climb to the surface.

Robbins took a drink from his water flask. Then he shouldered his backpack and turned around. In the gloom of the gallery he looked like one of those men in his old black-and-white photographs. We passed a row of ore hoppers filled with worthless clumps of rock broken from the ceiling before reaching the ladder. We clipped our lamps to our belts again and began our ascent. Dust from Robbins's shoes drifted down onto my head, and I could hear how his breathing grew heavier with each step. I could only imagine what that climb must have been like for the workers after eight hours of drudgery.

Robbins suddenly stopped. With one hand he held tight to the ladder while he stretched out the other one toward a shelf on the shaft wall. Then he raised his hand, and between his fingers hung a skeleton covered with brown skin. He studied it in the light of his lamp. A mummified rabbit. He carefully carried his find the rest of the way up, thinking it a fine decoration for the saloon he opened

in one of his renovated buildings in Gold Point. The first rays of daylight lit the shaft above us, and soon we had scrambled up the last of 381 steps. Once we stepped out onto the bright, hazy desert, it took a while before I could get Robbins in focus. He was covered with dust from head to toe, and his hands had the yellow-gold color of the ground.

Nevada didn't attract people. The first pioneers in search of a new life in Oregon and California crossed this country—possibly even noticed that their wagon wheels left glistening metallic tracks in the ground. But they hurried on. They felt that this was no place to settle down. The mountains of Nevada could well have kept their secret forever, but then in January 1848 gold was discovered during construction of a mill on the American River in California. Once the news crossed the continent there was no holding them back; the great trek westward began. A few got lucky and grew rich. Most, however, lost their last dollar. "A gold mine," Mark Twain is reported to have said, "is a hole in the ground with a liar standing next to it."

The most audacious losers went back to try their luck in the mountains of Nevada, where they hit upon rich deposits of silver. Hornsilver was one of the latecomers. Construction of this tent town began only in the spring of 1908, by which time the silver era was practically history in many other parts of Nevada.

Hornsilver was one of the few camps that had an established silver mine before the major digging began—and not the reverse. Yet the boom ended quickly. Lawsuits over mining rights brought many of the mines to a standstill, and inefficient working methods often cancelled out any profits. The town expanded and shrank depending on the quantity of silver recovered and its price. In 1908 Hornsilver numbered some seven hundred inhabitants; two years later there were only fifty. Then in 1916, when the price of gold rose to $20.67 an ounce, the town welcomed two hundred new settlers. It even set up a school, but by 1925 there was no longer any need for one. "The town," one of its residents wrote, "is oppressively quiet."

Hornsilver would experience only one more boom after that, in 1932, when gold was worth $35 an ounce. At that time there was more gold being recovered from the mines than silver, so on October 16 of that year the town gave itself a new name: Gold Point. Then came the war. First the mine workers left, then the town's businesses closed.

Robbins lives at the entrance to town in one of the fifty-five wooden structures still standing. Over the course of the years he has bought quite a few of these. He and a friend now own twenty-eight of them, "including the outhouses, because they're historic too." It isn't easy to purchase buildings in Gold Point, even though most of them are in derelict condition and their owners live far away. People know that there is still gold in the ground they stand on and feel that someday their property could be worth something again.

Gold Point is one ghost town that is still inhabited, and perhaps it is lucky in that respect. Most of the West's abandoned ghost towns have virtually disappeared, having been plundered or used for target practice. A few have been turned into museums or amusement parks. Just as these mining camps once served as the

very embodiment of the American dream, in their desolation they stand as eloquent reminders that in such a country history is either glorified or forgotten. Although Gold Point was only a footnote to the Gold Rush, Robbins refuses to let it vanish from memory. That's why he can be seen scrambling about on the town's leaky roofs with his hammer and shingles. He has renovated three of his shacks and turned them into guest rooms and converted the Hornsilver Townsite & Telephone Company building into a saloon. To the few visitors who make their way to Gold Point he serves steaks for breakfast and Kentucky bourbon for dessert. If they wish, they can use his shower—as long as there's water in the tank. He refuses to lay pipe to the reservoir three miles away. He's not interested in having the running-water type of tourist.

Robbins uses the money he takes in from hosting guests to fix things up. But he is no longer so dependent on this since he made his own lucky strike. It is not without irony that the vein of gold he hit was wholly associated with the modern era. On an April day in 1998 he hit the jackpot in a Las Vegas casino: $222,636. He grinned as he told me about it. It was dark outside, and off in the distance a coyote was howling. The winching tower of the Great Western Mine looked like a gallows silhouetted against the sky.

The next morning Robbins took me over to the post office. He pushed open the door, tripping a loud bell, and for a moment it seemed that Ora Mae Wiley, the town's last postmistress, would promptly appear at the window. Next to it were tacked FBI posters from the 1950s. David Dallas Taylor, alias Clyde Anderson, FBI No. 53,894A, was wanted for murder. Virginia May Iser, alias

Mrs. Larry Blake, FBI No. 266,910B, had robbed a bank. Taylor was armed and dyed his hair, Iser had a pretty face and was an excellent markswoman.

On one wall stippled with gold dots hung Mrs. Wiley's oath of office and a list of postage rates from an era when it cost 4¢ to send a postcard. Her stool still stood behind the counter as if she had simply stepped away for a moment and never came back.

When the post office opened in June 1908, the reporter for the *Hornsilver Herald* enthused: "Last Wednesday, for the first time, letters were delivered in the new post office, the handsomest post office in the West." Ora Mae Wiley came to Gold Point much later, in the early 1940s. She not only ran the post office, but also kept a small grocery store and pumped gas at the filling station next door. She let a lot of her customers run a tab, and sometimes she would cook for the mine workers and nurse them when they were sick. After the last of the mines had closed she wrote in her diary: "It's the dreariest time in the nine years I've been here."

For a quarter of a century Mrs. Wiley sat behind the post office window, and it was a rare day when she didn't wear a smile. Now there is a picture of her on the desk where she canceled the stamps on letters. Her hair is gray and wavy, and she wears a knitted jacket and glasses that narrow to a point at the sides. She is smiling. When Mrs. Wiley got up from her stool for the last time, Gold Point had long since grown too small to have its own post office. The office closed on January 12, 1968, and Gold Point was left to become a ghost town forever.

MARIO KAISER

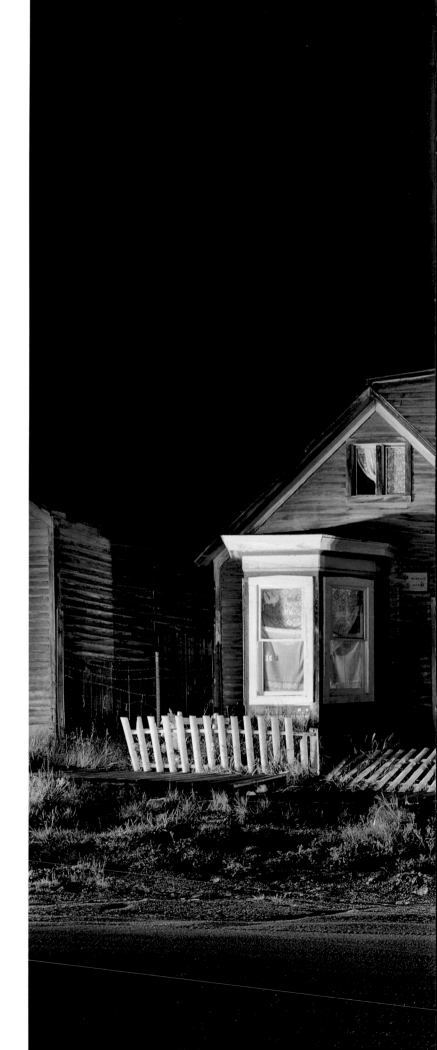

ST. ELMO, COLORADO

The settlement of St. Elmo was founded in 1878, and as the population grew it changed from a peaceful, well-kept community into a typical Wild West town with saloons, carousing, and shoot-outs. The Home Comfort Hotel, the focus of social life in town, was erected in 1885. Stark Brothers Mercantile, a store selling general merchandise, opened in the same building in 1909 with a large inventory of wares required by mine workers, and complete with a post and telegraph office. The store closed in 1958, as St. Elmo was gradually becoming a ghost town.

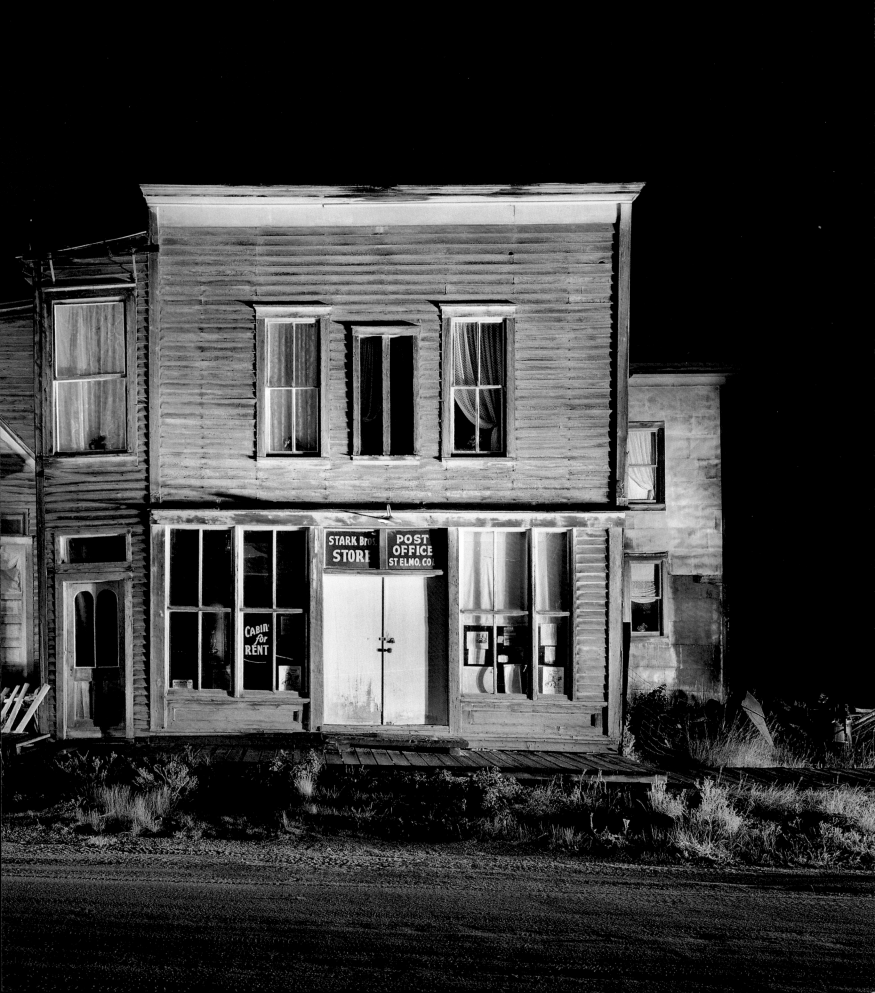

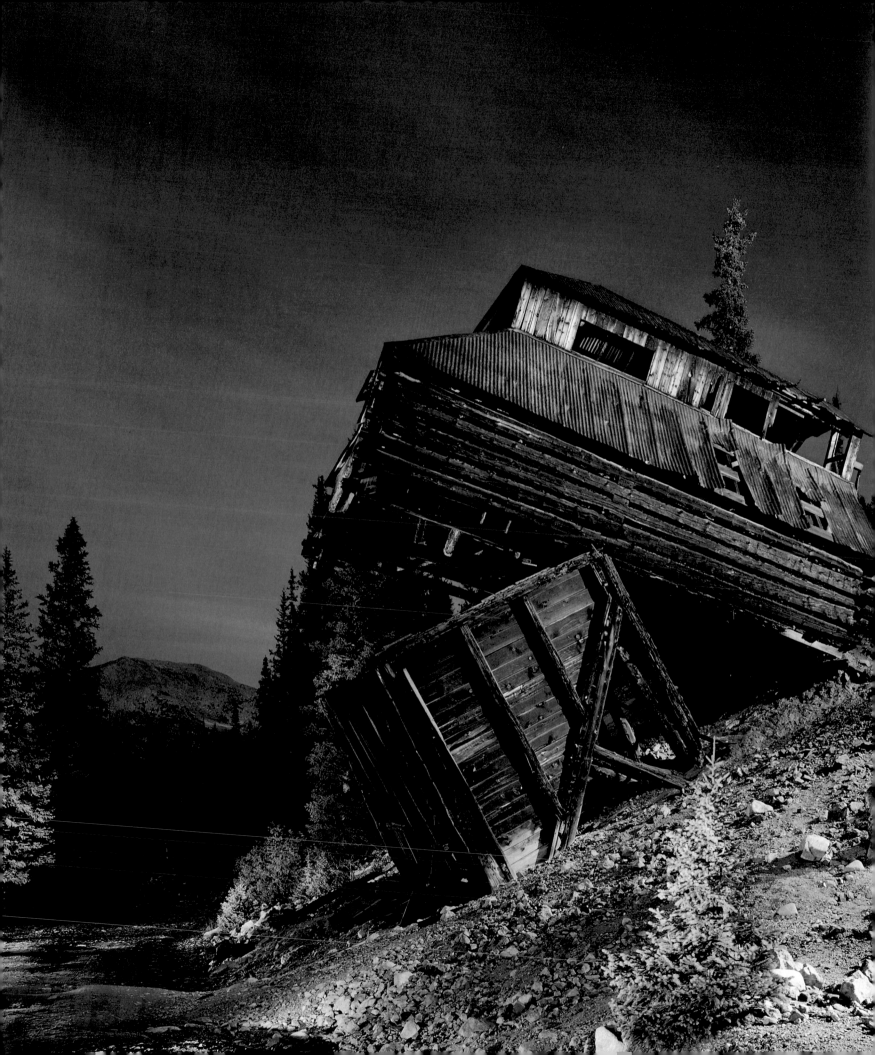

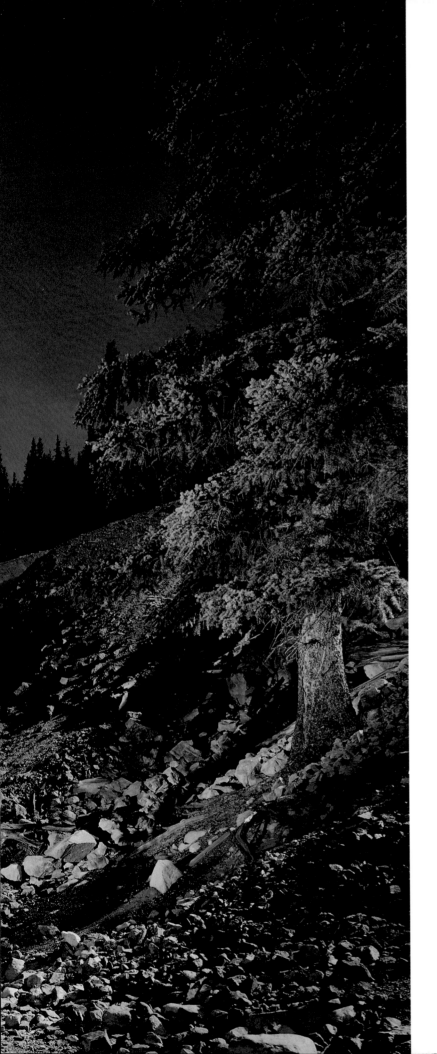

ALLEY BELLE MINE, COLORADO

Around 1880 the mountains around Chalk Creek Canyon were pocked with mines and the forests in the area were barren due to logging. At that time the tracks of the Denver, South Park & Pacific Railway still led across the Rocky Mountains, allowing ore from the Alley Belle Mine to be loaded onto freight cars and taken down into the valley for further processing. Avalanches and slides have shifted the former Alley Belle Mine building off its foundation. Only sparse remnants of the onetime settlement can be found in the nearby woods that have slowly grown up again since 1926, when the train tracks were removed and the mining town of Hancock was abandoned.

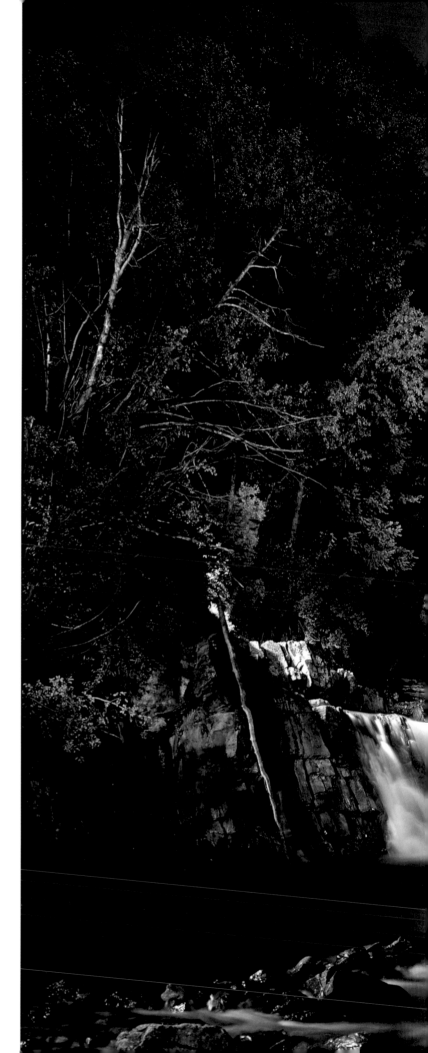

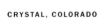

CRYSTAL, COLORADO

Sheep Mountain Tunnel Mill, water mill and compressor building. In the 1890s silver, as well as gold, was discovered in the underground storage rooms on the Crystal River. But mining in this remote Rocky Mountain region was extremely difficult, especially transporting the necessary machinery. In 1892 this small water mill was built to provide compressed air for the drills in the nearby mines.

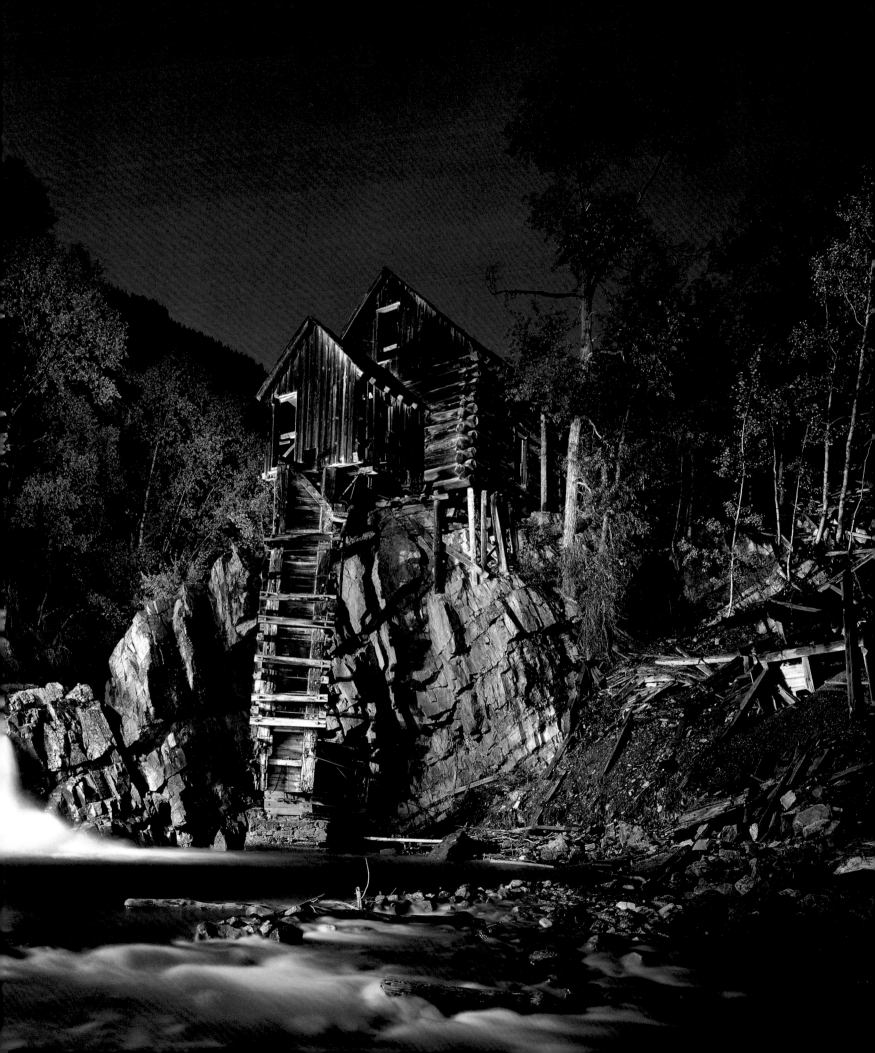

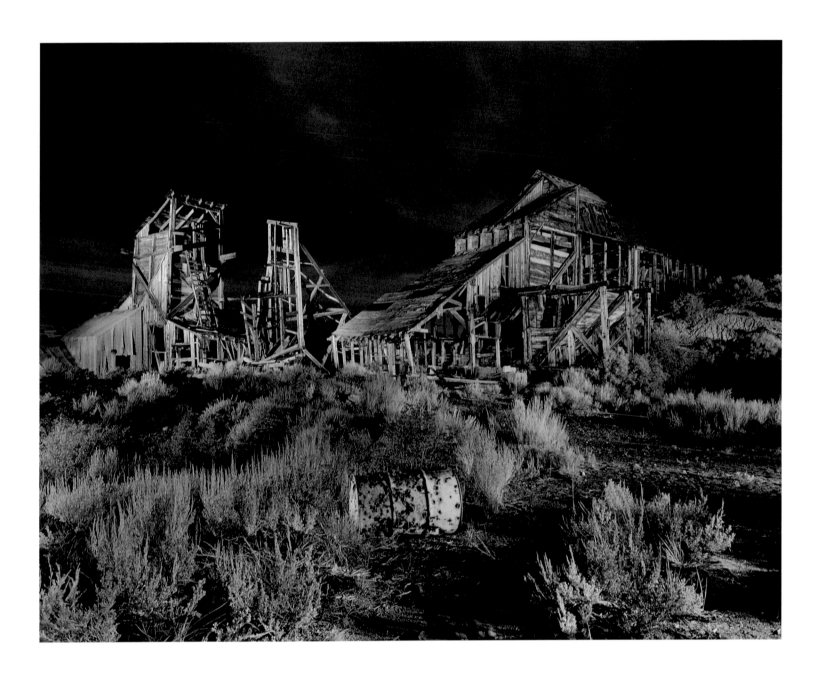

CHEMUNG MINE, CALIFORNIA

Bullet holes in drums, shacks, and cans attest to a turbulent past. The old
tracks used to transport gold from the mine to the nearby town of
Masonic are still in place.

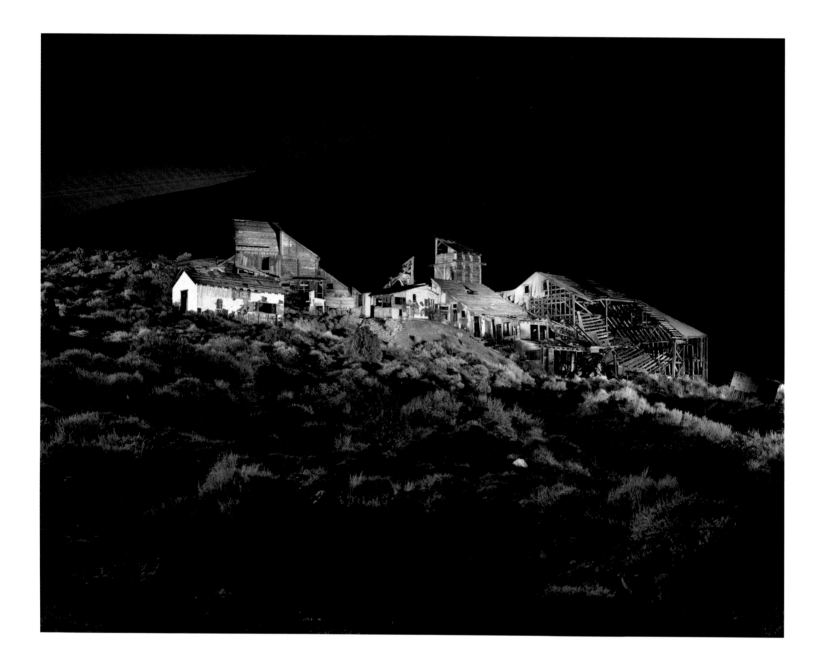

CHEMUNG MINE, CALIFORNIA

A mine's fate always affected the surrounding town. When gold was discovered on the eastern slopes of the Sierra Nevada in about 1860, boomtowns like Masonic sprang up in record time. In 1938, once the gold reserves in the Chemung Mine had finally been exhausted, Masonic was left to become a ghost town. Today the former mine buildings are all that is left to remind visitors of the exhausting labor of the mine workers.

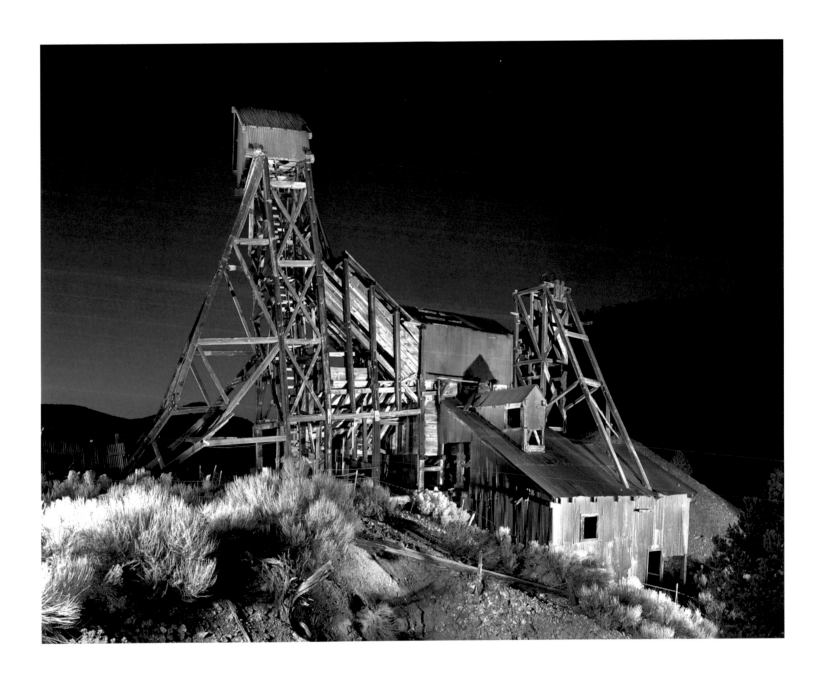

GOLD SPRINGS, UTAH

Big Buck Mine. Big companies tended to drive independent miners out
of business. Most small operators could not afford the machinery needed
to get at the gold in deeper veins of quartz.

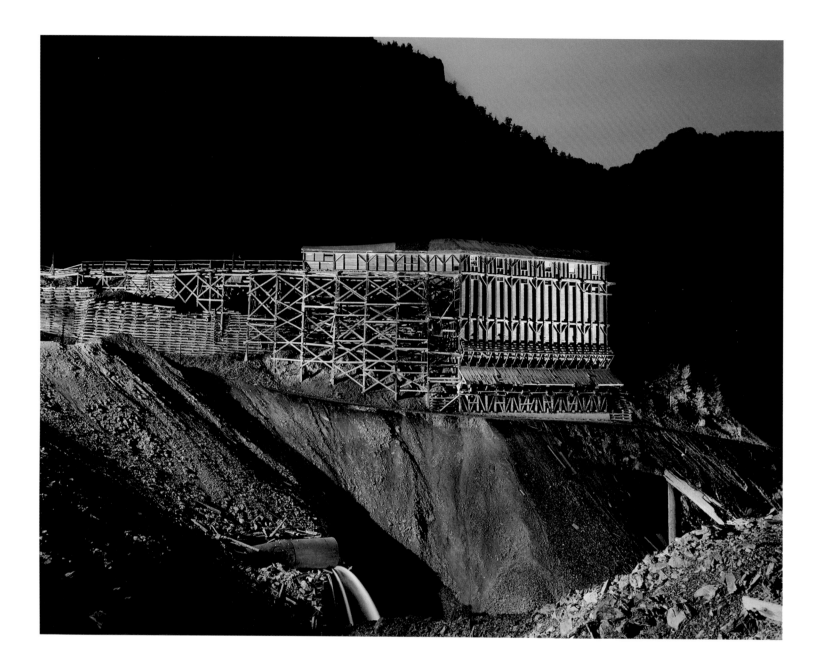

CREEDE, COLORADO

The Commodore Mine was part of one of the largest silver-mining districts in the world,
operating from 1891 to 1976. Nearly two hundred miles of tunnels snaked through the inside
of the mountain. In the early years ore wagons drawn by mules stopped at loading points
from which the ore was transported down steep roads for processing in the valley.

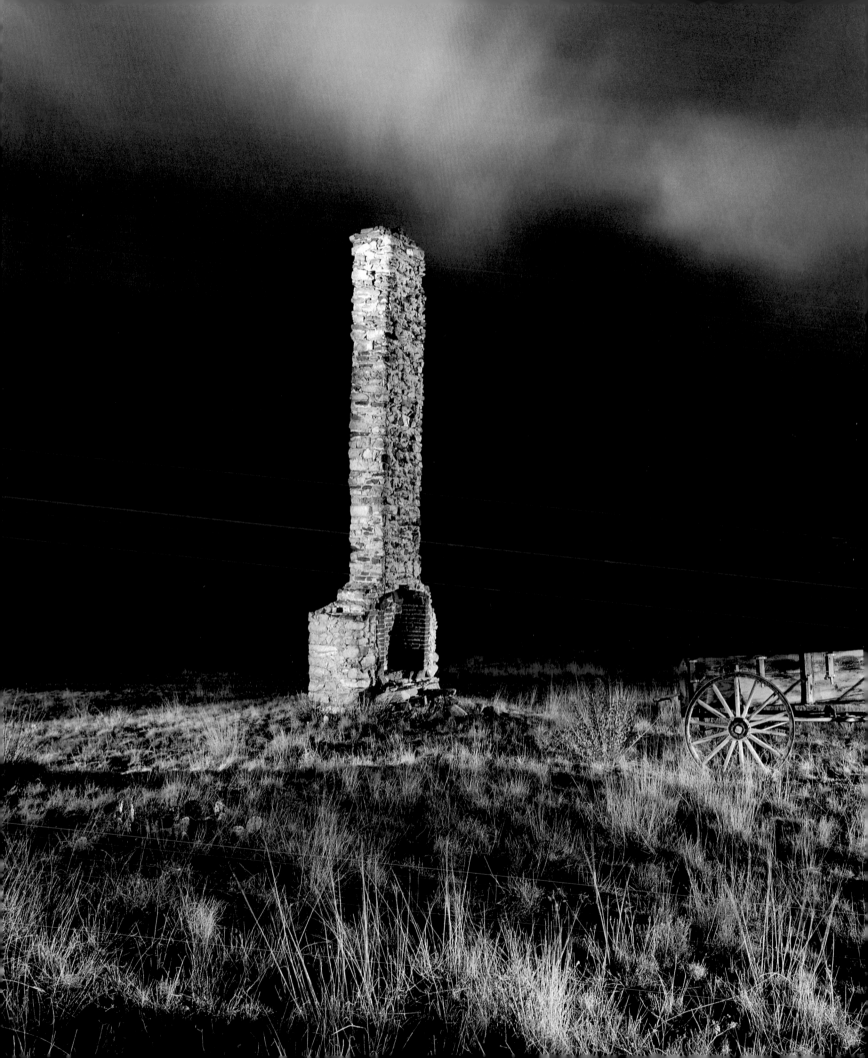

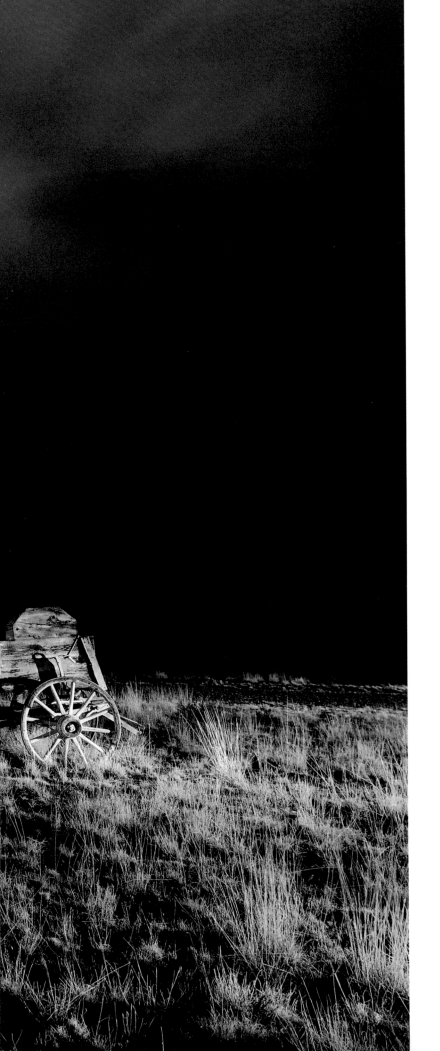

MASSICKS, ARIZONA

A storm passes across Prescott Valley, where a chimney and an old covered wagon recall the town of Massicks. In the late nineteenth century, gold miners searched the riverbanks for placer gold that could be recovered without expensive machinery. Deposits in the sand and gravel banks were soon exhausted, so expensive machinery was needed to dredge the river. Several hills next to the river were leveled by plying them with jets of water under high pressure, but profits were too small to keep workers here for long. The operation closed down in the 1930s.

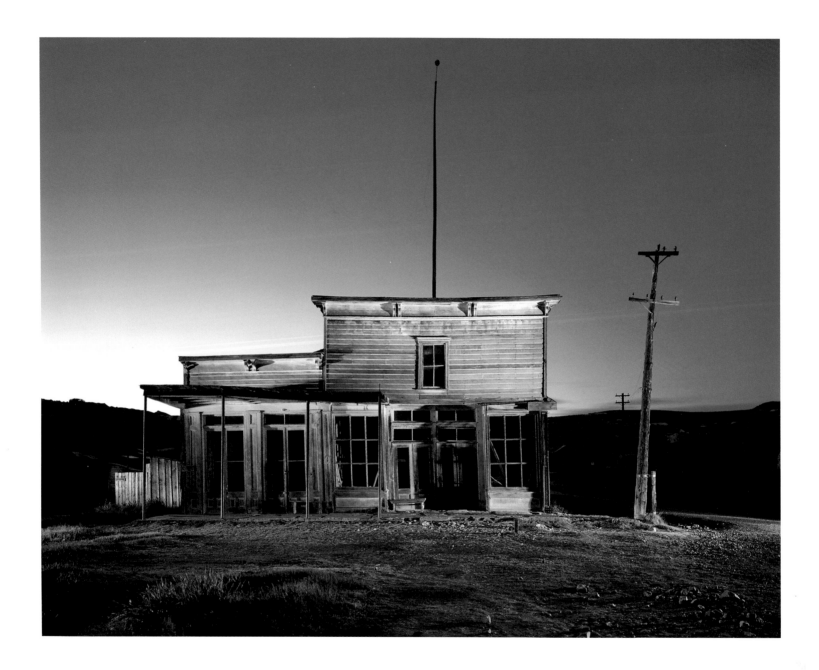

BODIE, CALIFORNIA

Wheaton & Hollis Hotel, corner of Main and Green Streets. "Goodbye God! We're going to Bodie," wrote a young girl as she set off from San Francisco for Bodie in about 1879. The town's reputation was indeed highly unsavory—it was considered one of the wickedest places in the West, exemplifying all the clichés of a classic Wild West town: saloons, shootings, easy women, and a chance at enormous wealth.

It all began with William Waterman S. Body. When the gold rush in the Sierra Nevada gradually petered out, he crossed the mountains to dig for buried treasure on their eastern slopes. On Bodie Bluff in late 1859, while digging a rabbit out of its burrow on a hunting trip, he hit upon one of the richest veins of gold in California. His luck was short-lived, however, for later that same winter he froze to death trying to get back to his shack. When the mining camp gave way to a proper town it was named Bodie after the deceased prospector.

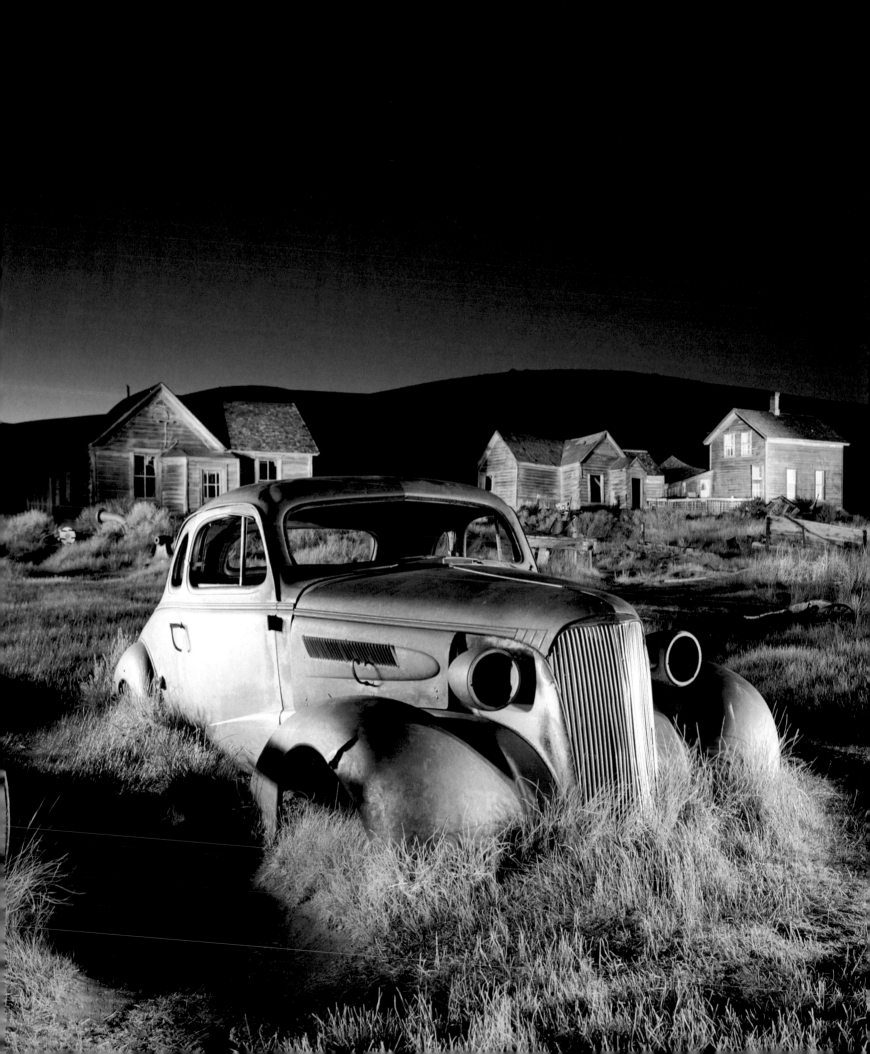

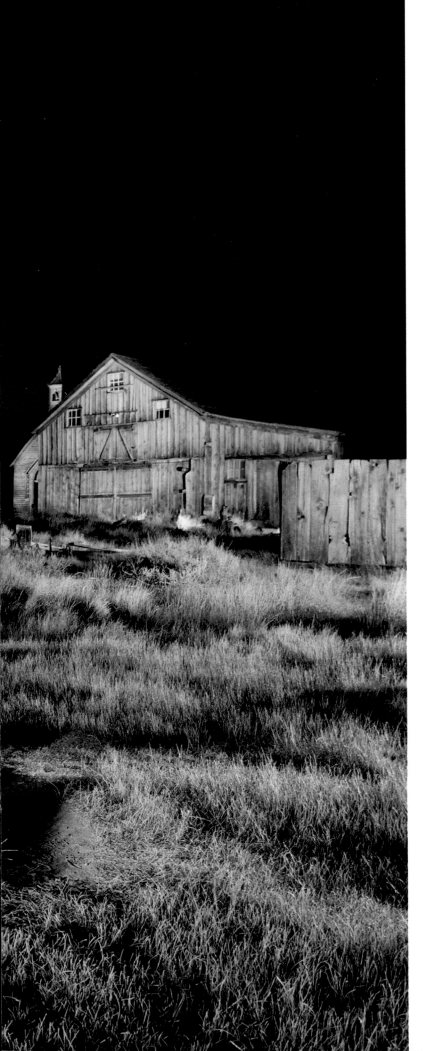

BODIE, CALIFORNIA

The skeleton of a 1937 Chevrolet coupe in front of some of the town's surviving structures. A fire in 1932, set off by a boy playing with matches, destroyed most of Bodie's buildings, and they were never rebuilt. Even the revival of the inactive gold mine failed to give the place a boost, and in the 1940s Bodie became a ghost town.

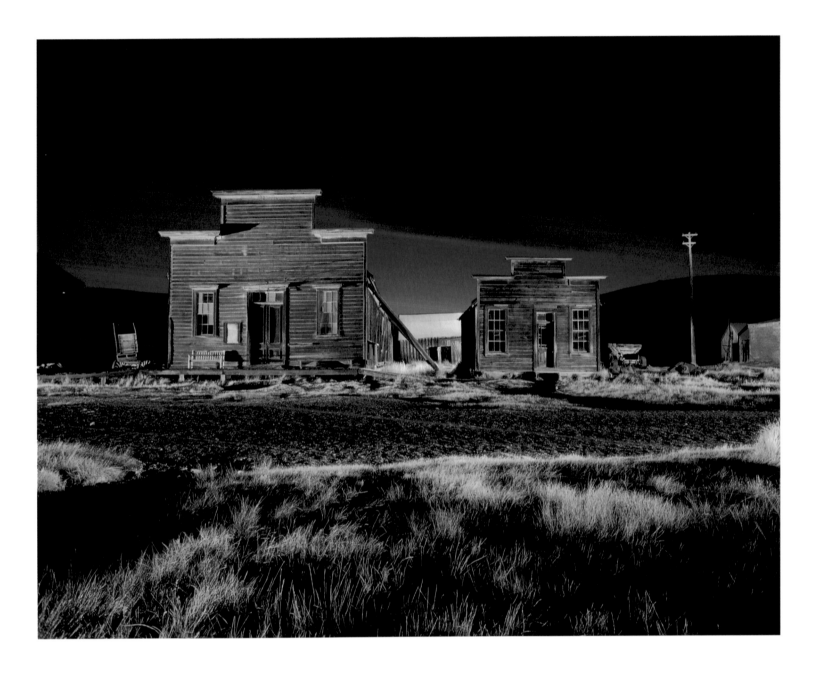

BODIE, CALIFORNIA

Miners Union Hall on Main Street, with the undertaker's establishment to the right.
The union hall was an important social and cultural meeting place in Bodie. It was here
that big Fourth of July celebrations took place.

36

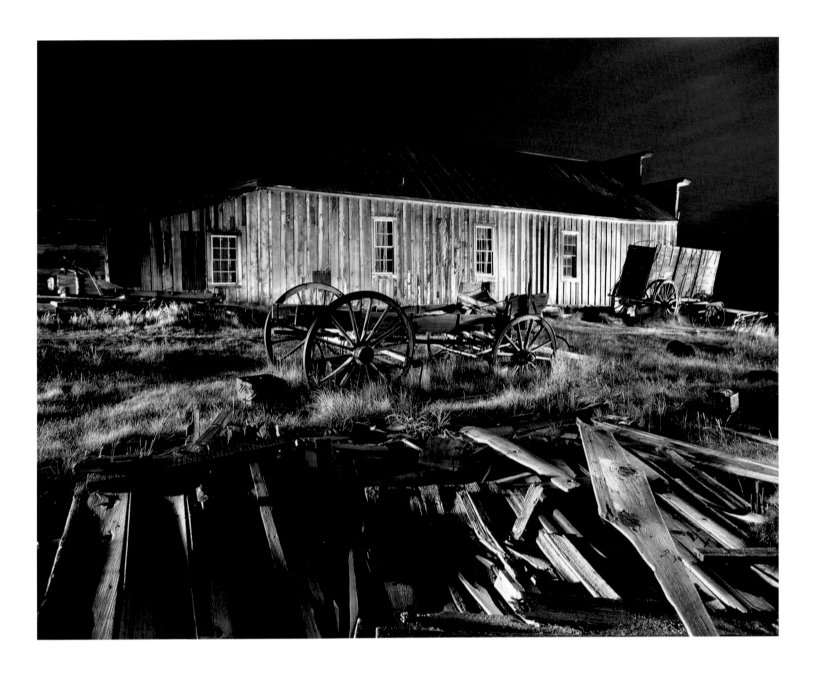

BODIE, CALIFORNIA

Wagons in front of the Miners Union Hall. Winters were long and hard, and firewood was scarce and expensive. In the winter of 1878 one man treated his woodpile with dynamite to protect it from thieves. When his next-door neighbor's stove exploded, taking part of the house with it, it became clear who had been stealing from him.

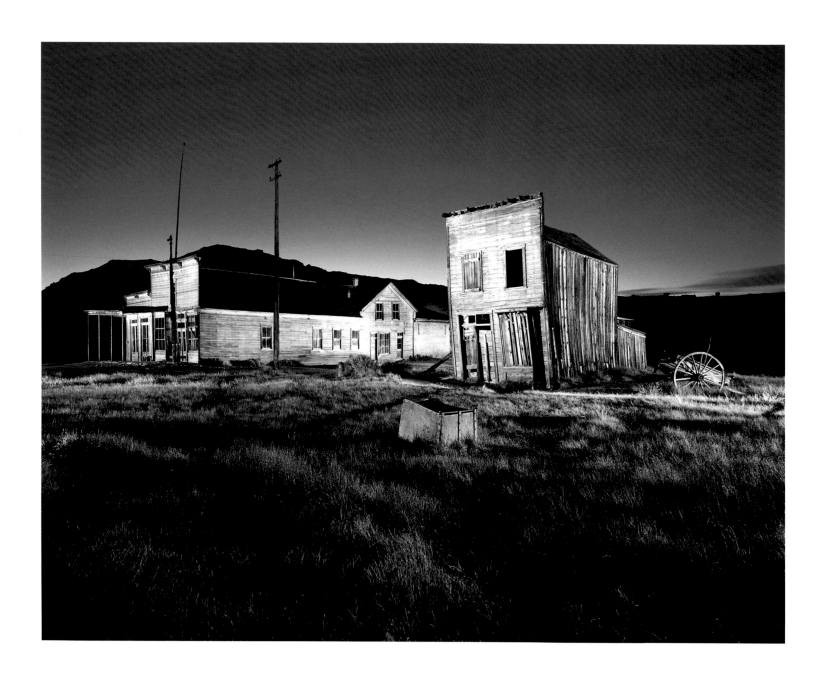

BODIE, CALIFORNIA

Swazey Hotel (right) and Wheaton & Hollis Hotel. In winter the snow was several yards deep. It was said that in spring the mud was so deep that you could only cross the street by stepping on the heads of mules.

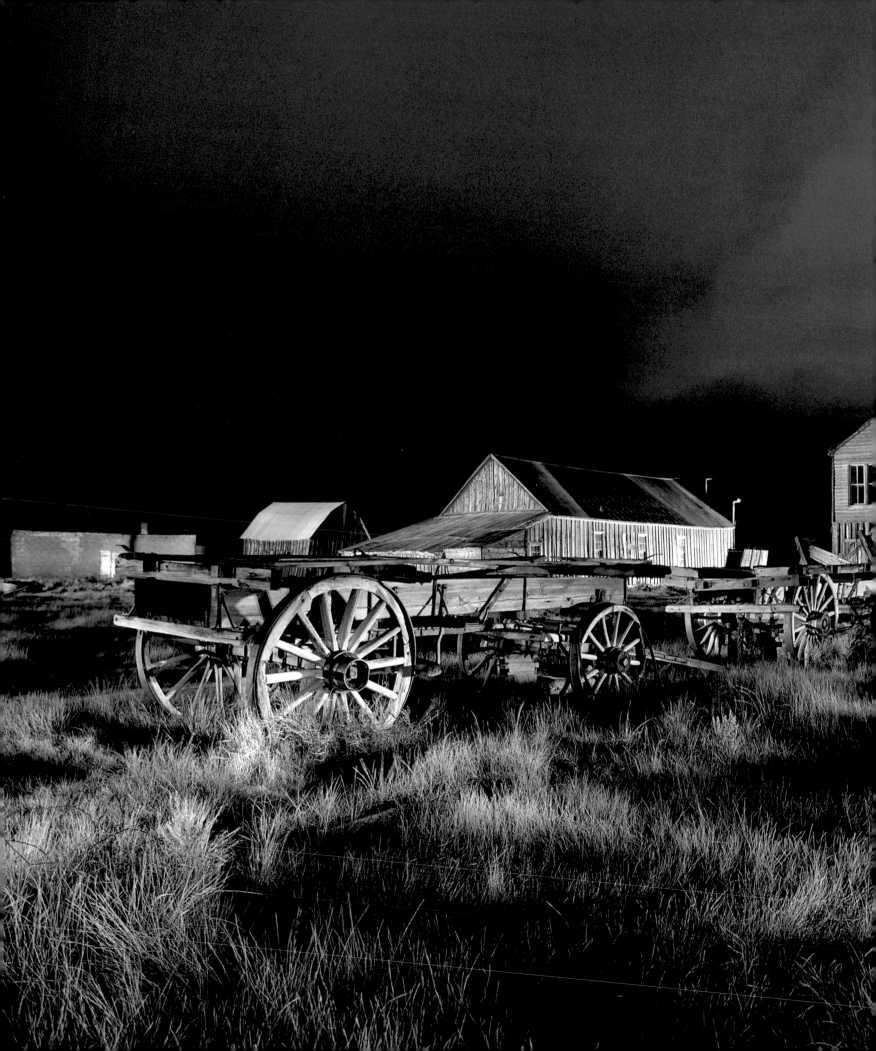

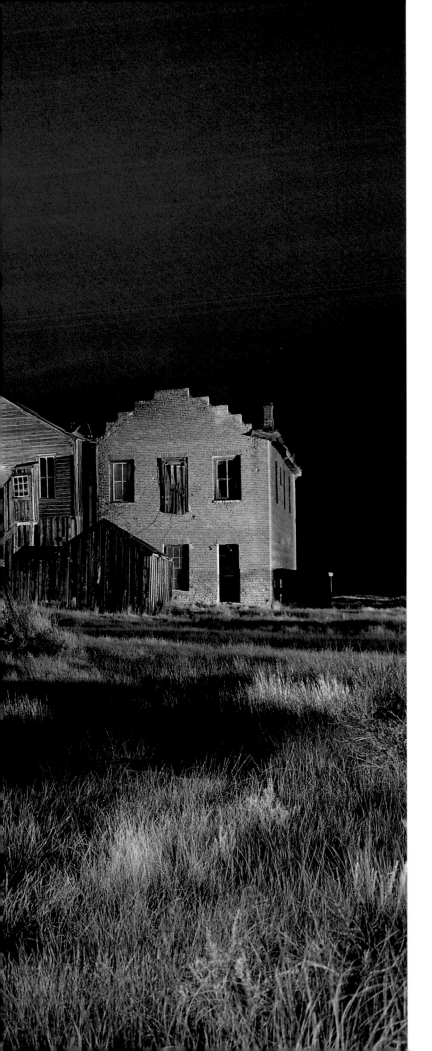

BODIE, CALIFORNIA

Wagons along Main Street. In 1859 only some twenty mine workers lived in Bodie, but with the mine's success the population soared and by 1879 it numbered more than ten thousand. Food and fuel could not be got locally, and had to be brought across the mountains in mule-drawn wagons.

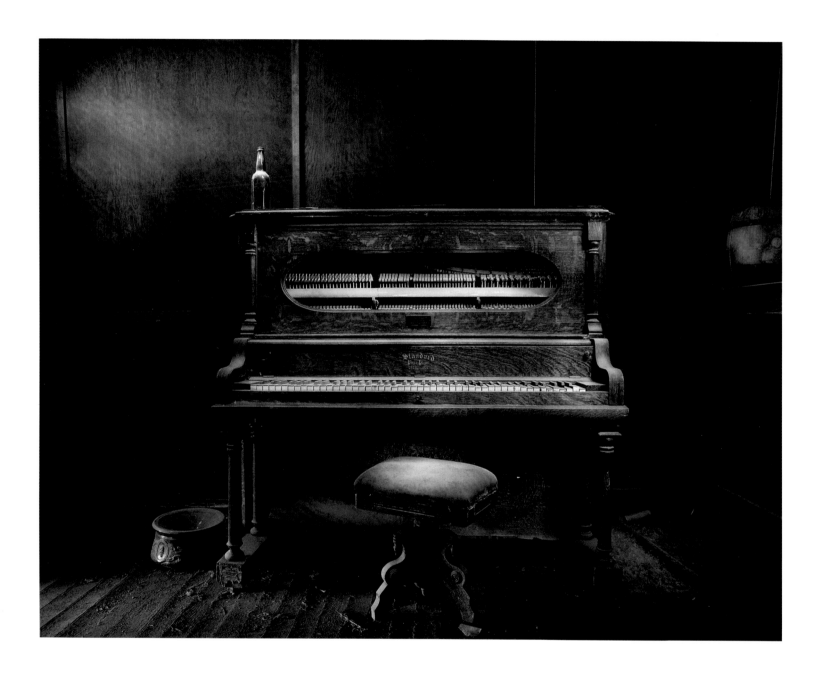

BODIE, CALIFORNIA

The piano in the Sam Leon Bar still echoes the boomtown's riotous nightlife. Thanks to its
high elevation and dry climate, what is left of Bodie has been largely preserved from rust and
decay. In 1962 the state of California placed the surviving buildings and their interiors,
roughly ten percent of the original town, under landmark protection. Bodie became a state
historic park. It is being preserved in a state of "arrested decay." Nothing is to be restored;
only time will be permitted to alter what remains.

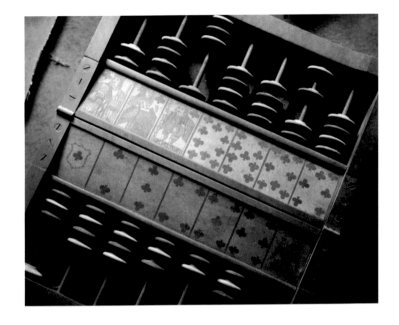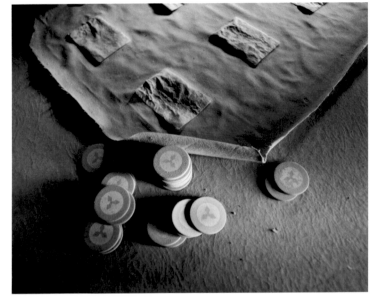

42

BODIE, CALIFORNIA

Sam Leon Bar. Entertainment in the gold miners' town was mainly provided by gambling dens and bars. Games like faro, in which players place their bets on cards, were extremely popular. Faro is thought to be the world's oldest game of chance using cards.

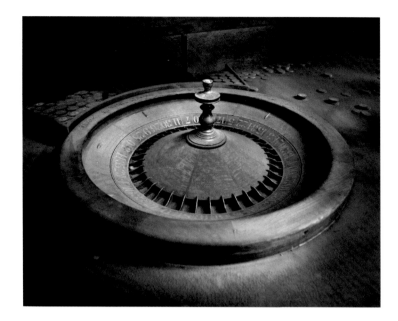
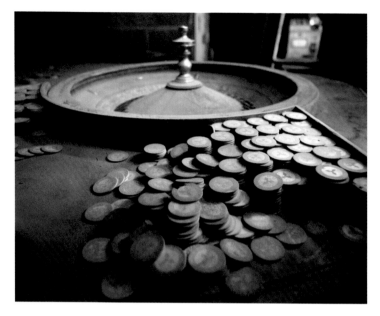

BODIE, CALIFORNIA

The roulette table in the Sam Leon Bar recalls Bodie's onetime wealth. At that time the number of saloons a town had served as an indication of its prosperity. Bodie is said to have had more than sixty.

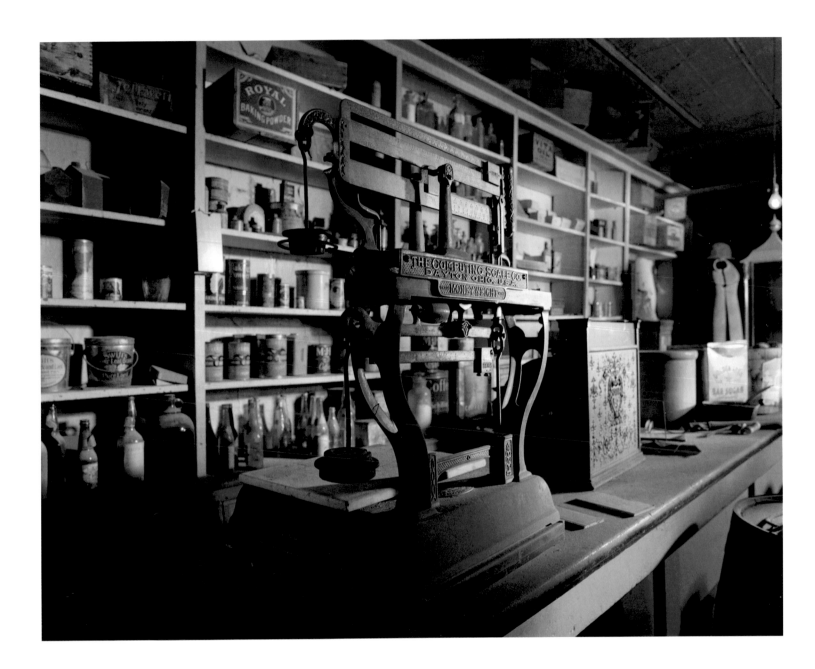

BODIE, CALIFORNIA

Boone Store & Warehouse on Main Street. Dust covers the shelves and displays in one
of Bodie's oldest stores, established in 1879, at the time of the town's economic boom.
Its interior furnishings are almost completely preserved.

BODIE, CALIFORNIA

Dust-covered treasures in the barbershop next to the Boone Store & Warehouse.

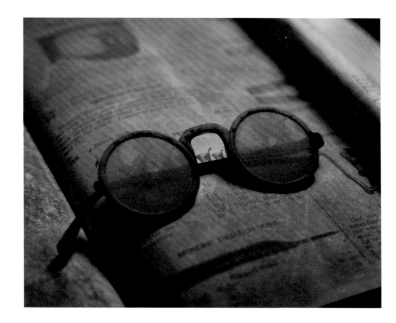 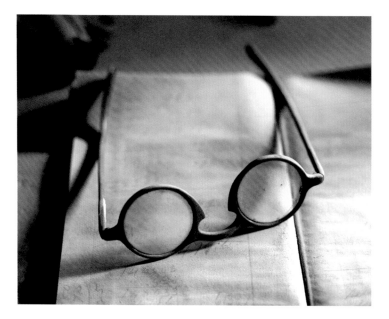

BODIE, CALIFORNIA (above)

Boone Store & Warehouse. These pairs of spectacles have lain
untouched atop the account books for decades, as if their owners
had only taken a short break for lunch.

BODIE, CALIFORNIA (opposite)

Boone Store & Warehouse. The store supplied Bodie's inhabitants
with groceries and general merchandise.

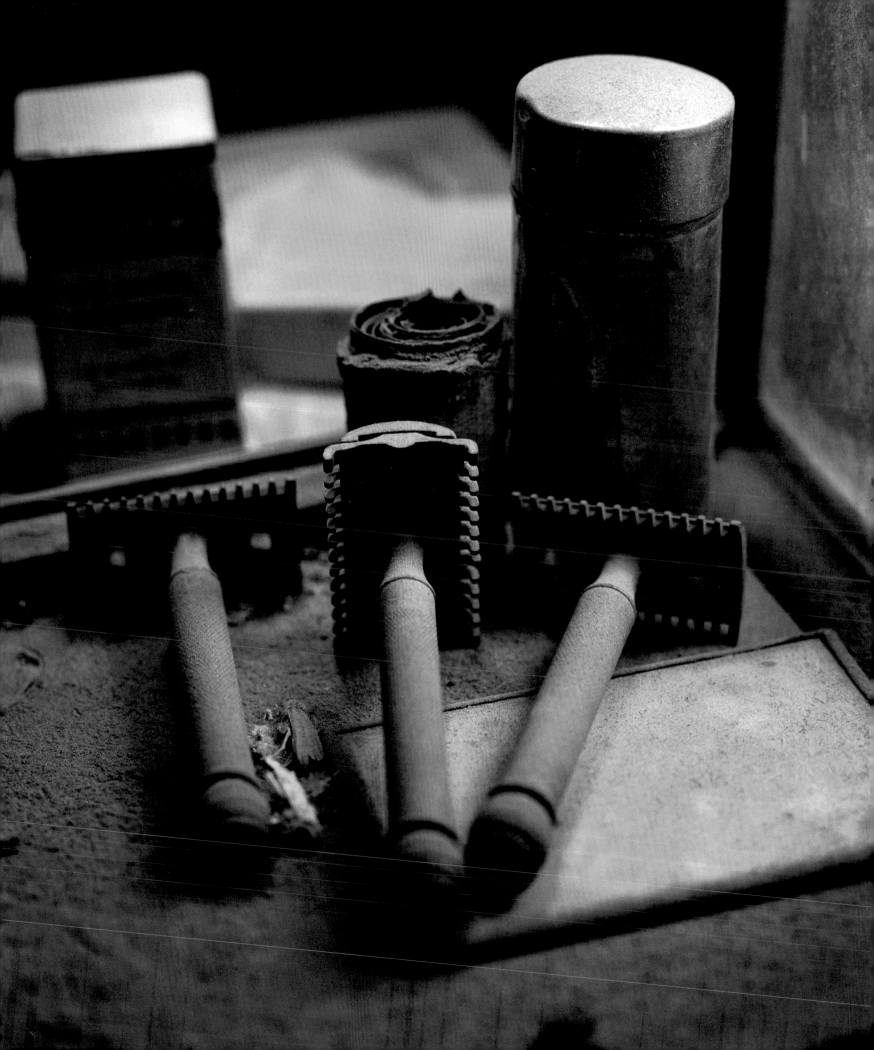

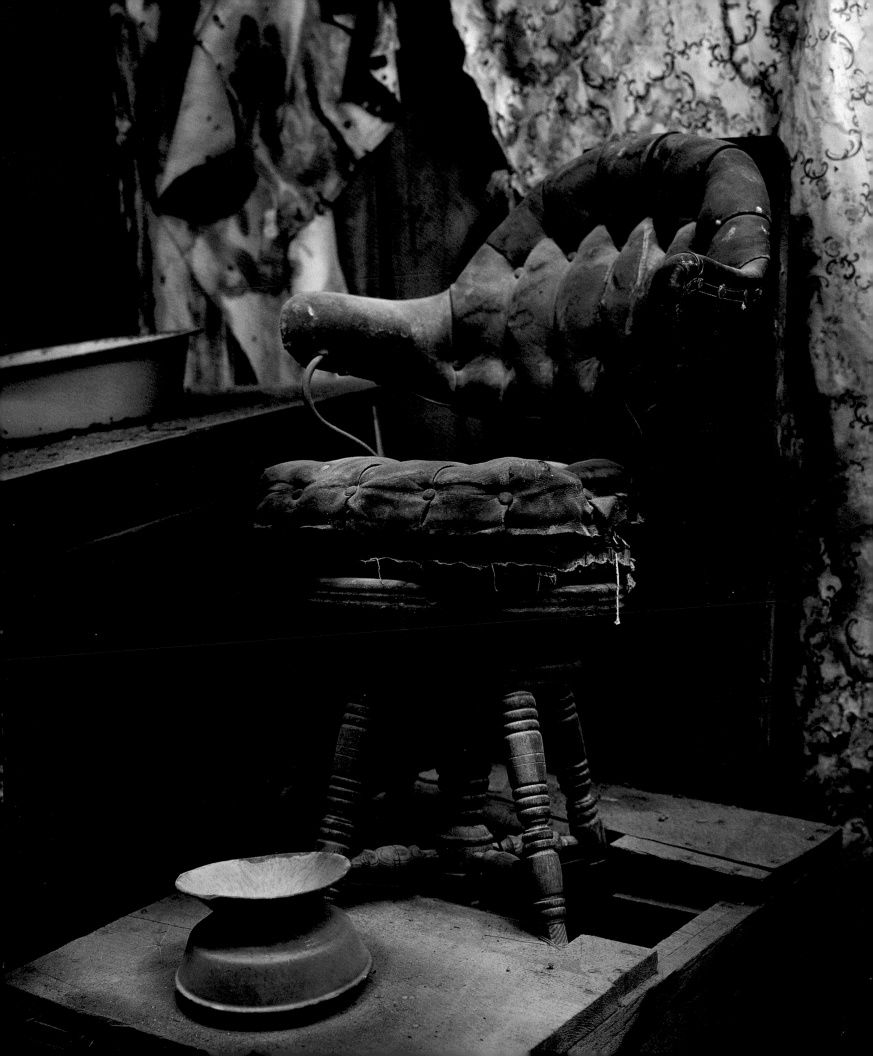

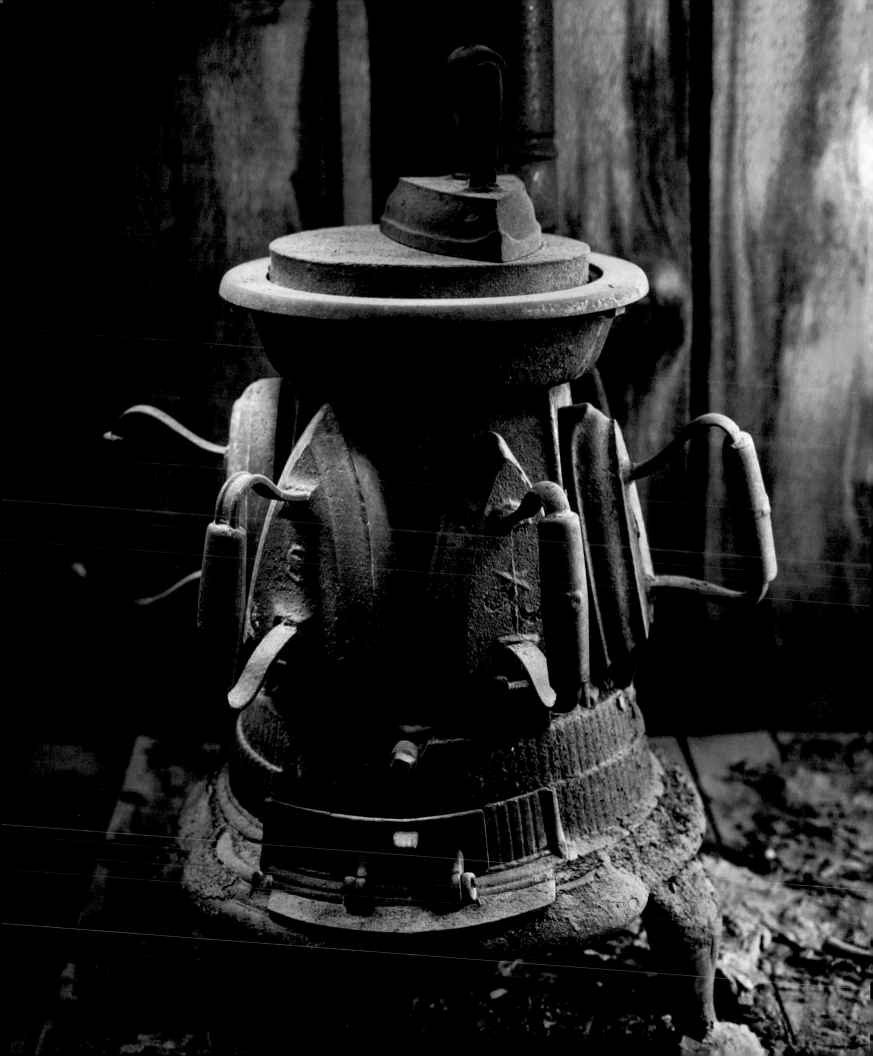

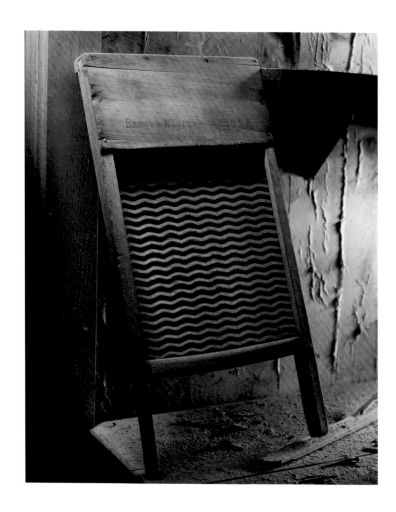

BODIE, CALIFORNIA (opposite and above)

Iron-heating stove and washboard in a Chinese laundry. The Chinese were discriminated against in the West. The only jobs open to them were in laundries or in the timber and vegetable trades.

BODIE, CALIFORNIA (page 49)

Barbershop chair.

BODIE, CALIFORNIA (page 48)

Boone Store & Warehouse. Shaving paraphernalia in the store's display window.

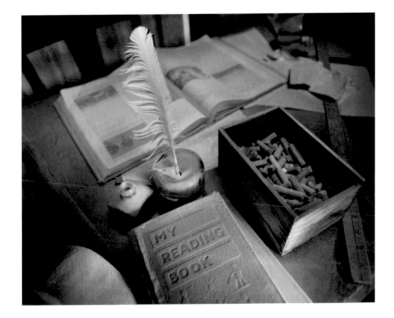

52

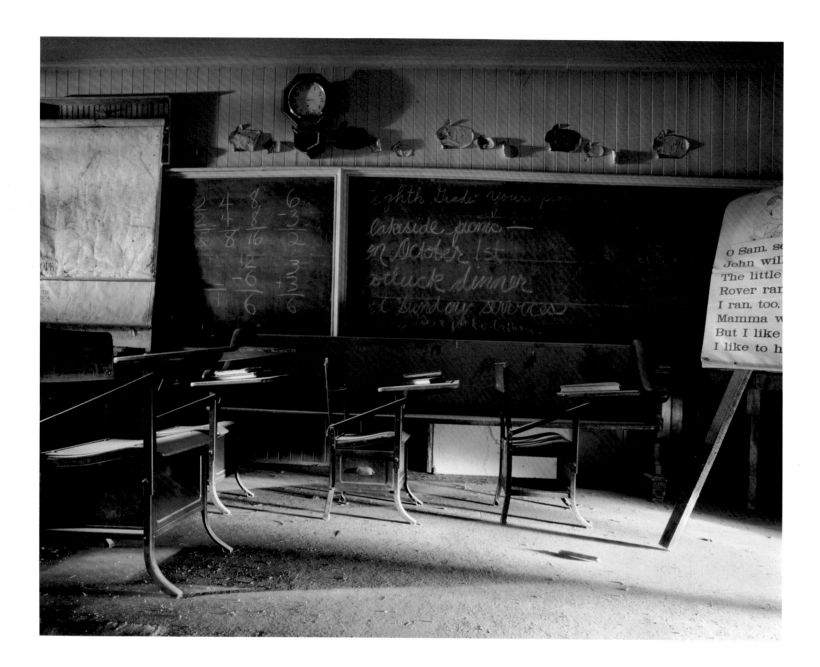

BODIE, CALIFORNIA

Classroom in the second schoolhouse. The first building was burned down by a little
boy the teacher had disciplined and sent home. With nothing else to do, he began play-
ing with matches in the dry underbrush behind the school. The fire engulfed the
schoolhouse and completely destroyed it.

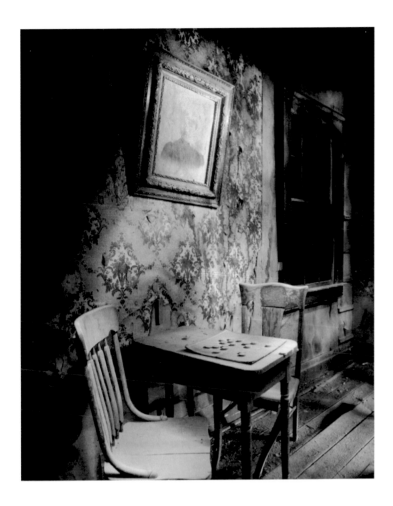

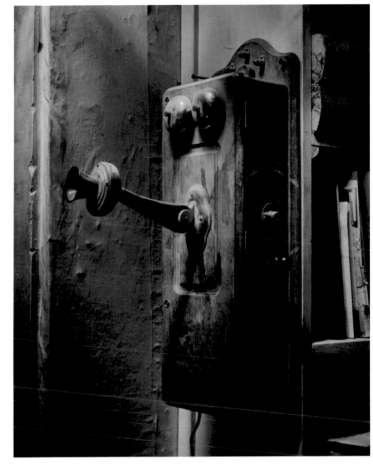

54

BODIE, CALIFORNIA

(above left)

Room in the Lottie Johl House. Lottie Johl began her career in the red-light
district, but gained respect as a painter and married the town's butcher.

(above right)

A wall telephone hanging in the Boone Store & Warehouse.

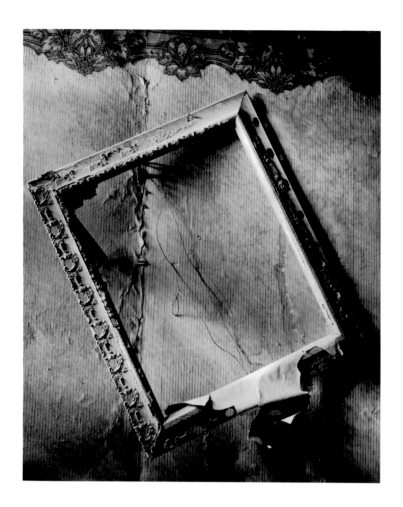

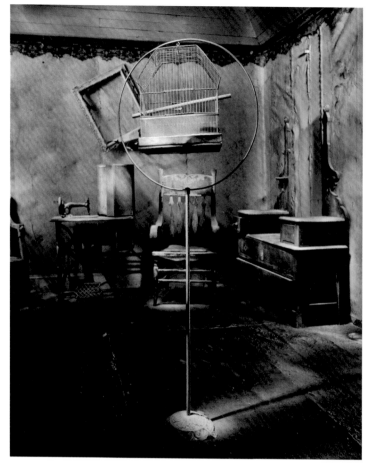

BODIE, CALIFORNIA

Houses in Bodie hold reminders of the town's last inhabitants.

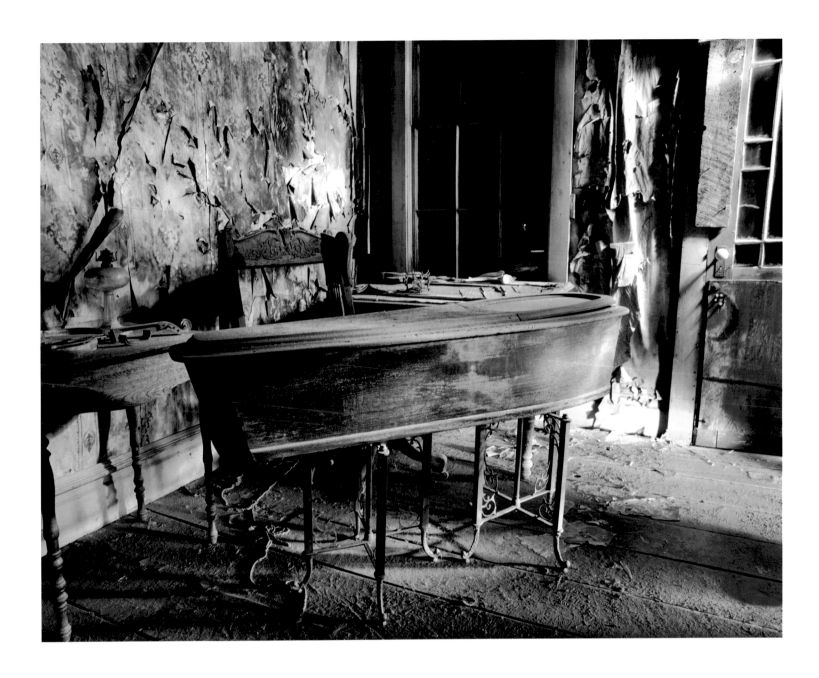

BODIE, CALIFORNIA

Coffin maker's workshop in the morgue. Trigger-happy gold diggers assured Bodie's
coffin makers and gravediggers a good living in the late nineteenth century. Shootings
and murders were everyday occurrences in this atmosphere of thievery, drunkenness, and
debauchery. In 1881 a local newspaper reported, tongue in cheek: "Bodie is becoming a
quiet summer resort—no one killed last week."

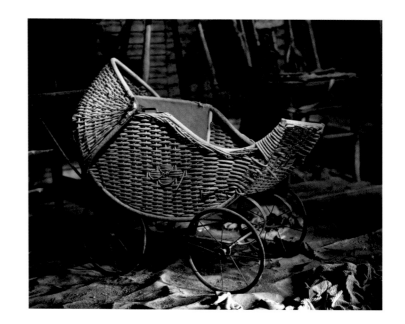

BODIE, CALIFORNIA

A baby carriage stands in the home of Lester E. Bell.

BODIE, CALIFORNIA

Wells along Green Street against the backdrop of the abandoned town.

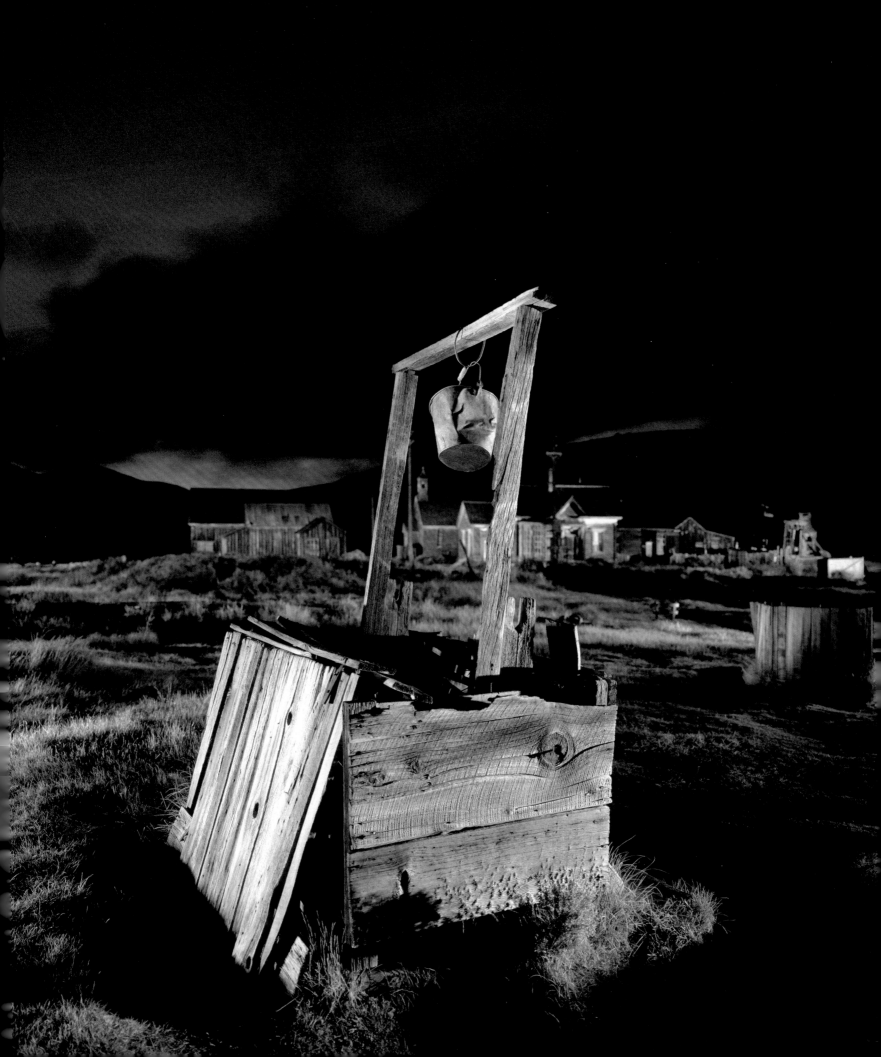

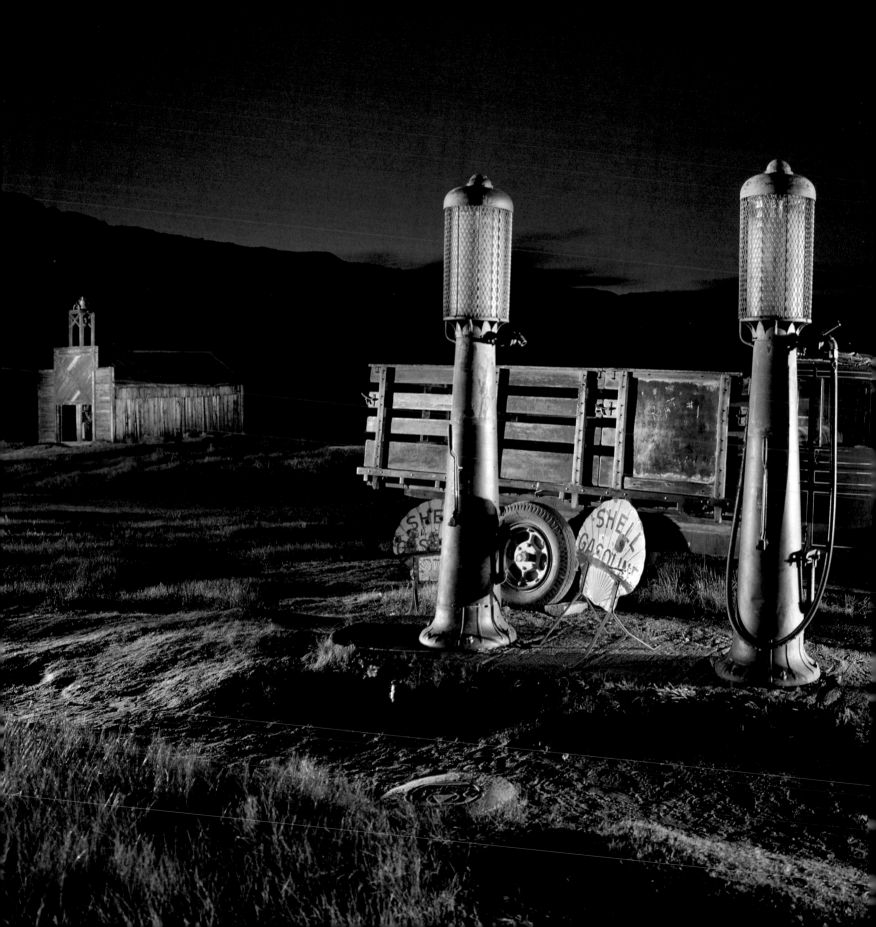

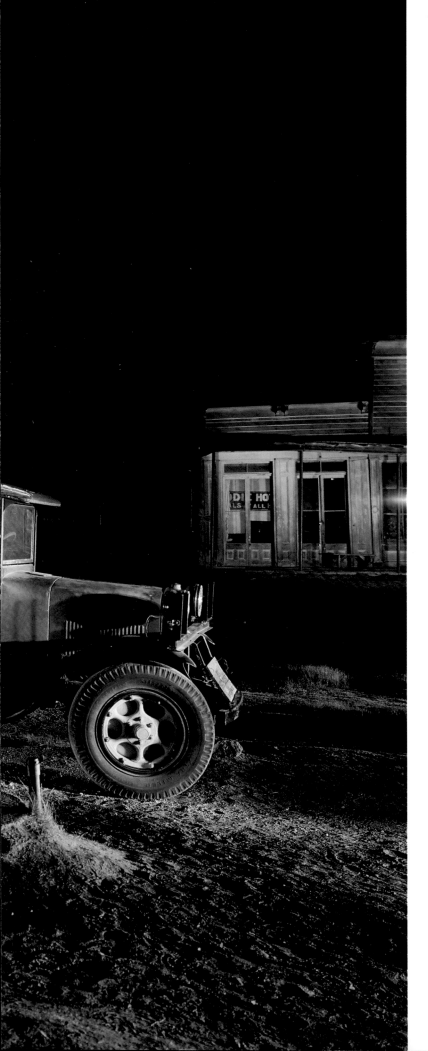

61

BODIE, CALIFORNIA

A 1927 Dodge-Graham truck stands parked at the filling station on Bodie's Main Street, as if the driver had just nipped into the nearest bar for a quick drink. Next door is the Boone Store & Warehouse. In the background to the right is the Wheaton & Hollis Hotel, to the left the small firehouse.

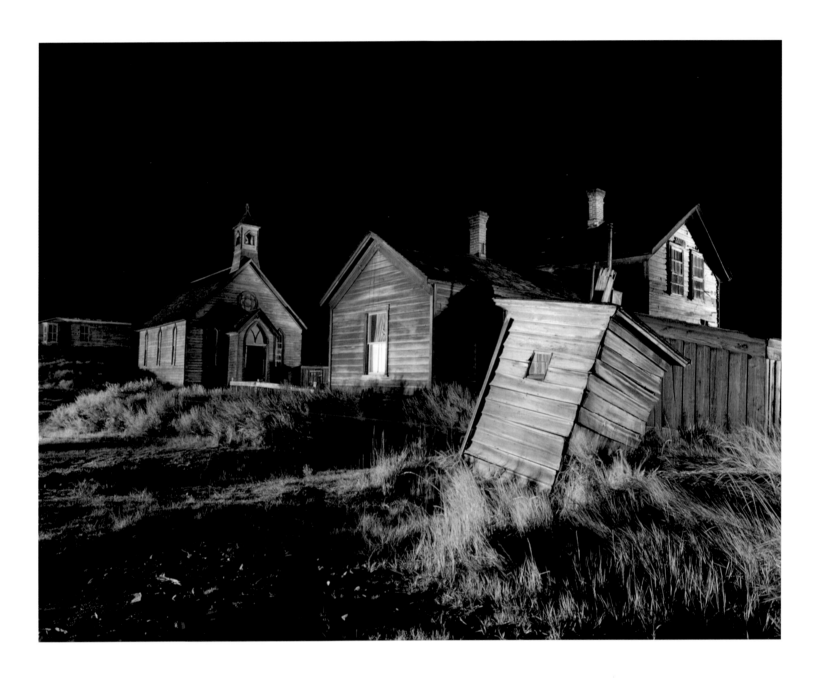

BODIE, CALIFORNIA

The Methodist church is the town's only religious structure to have survived the destructive fires of 1928 and 1932. For years Bodie had no church at all, but then in a single week in 1882 both a Catholic church and this Methodist church opened their doors—unfortunate timing, for in the previous year the population had shrunk from more than seven thousand to a mere three thousand souls.

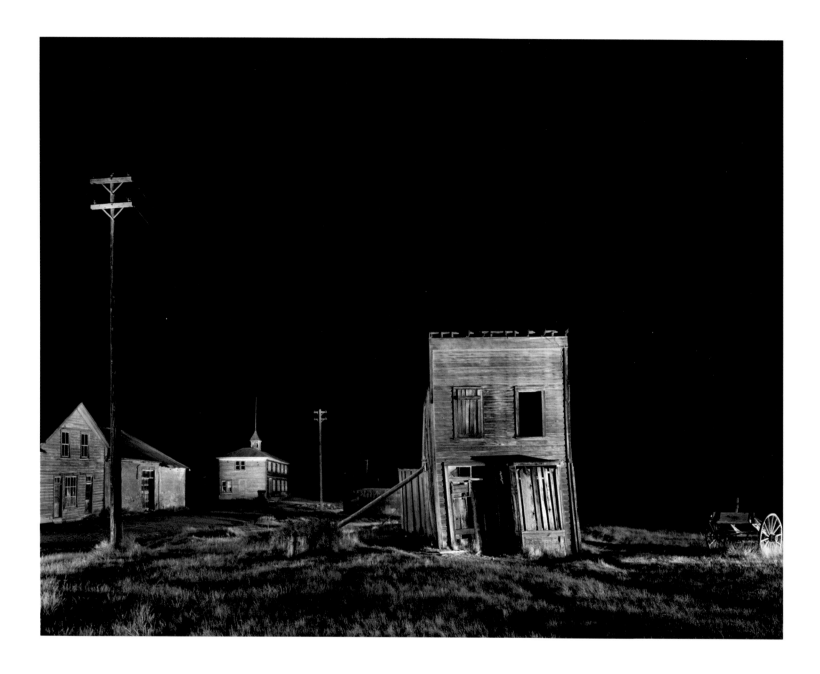

BODIE, CALIFORNIA

The tilting Swazey Hotel on Green Street. In the background, on Main Street, the
schoolhouse. Power lines in Bodie were run in straight lines, as it was believed that
the electricity could not turn corners.

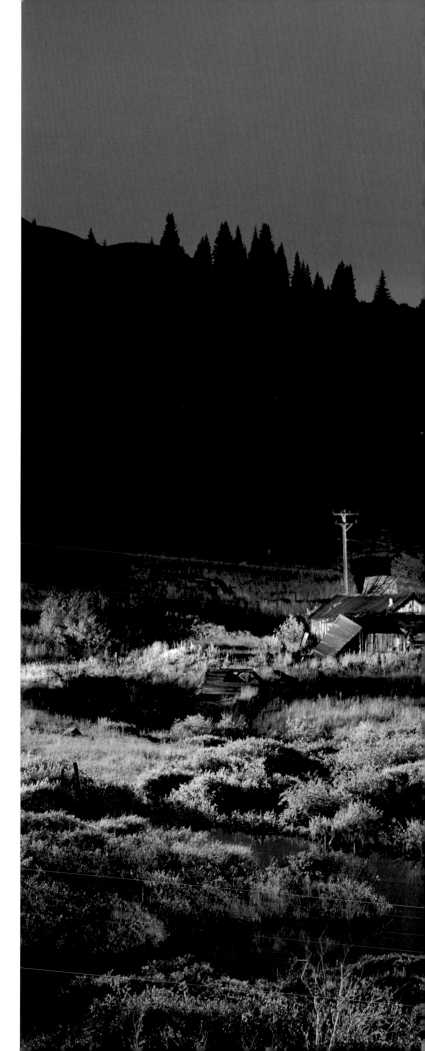

STUMPTOWN, COLORADO

In 1860 a canyon in the Mosquito Range became the scene of a wild rush for gold.
Two years later the California Gulch deposits were exhausted, and miners aban-
doned the place. When the prospector Will Stevens found silver in the abandoned
mines some thirteen years later, the Rocky Mountain valley experienced a new
frenzy. The town of Leadville and smaller settlements like Stumptown were estab-
lished. After the silver boom, minerals such as copper and zinc that were in
increasing demand in industry were also discovered. Many of the smaller settle-
ments were abandoned in the 1930s as people moved into nearby Leadville. Since
then the houses and mine buildings have fallen to ruin. Stumptown's fate is
unusual; its wooden shacks are slowly sinking into the swamp.

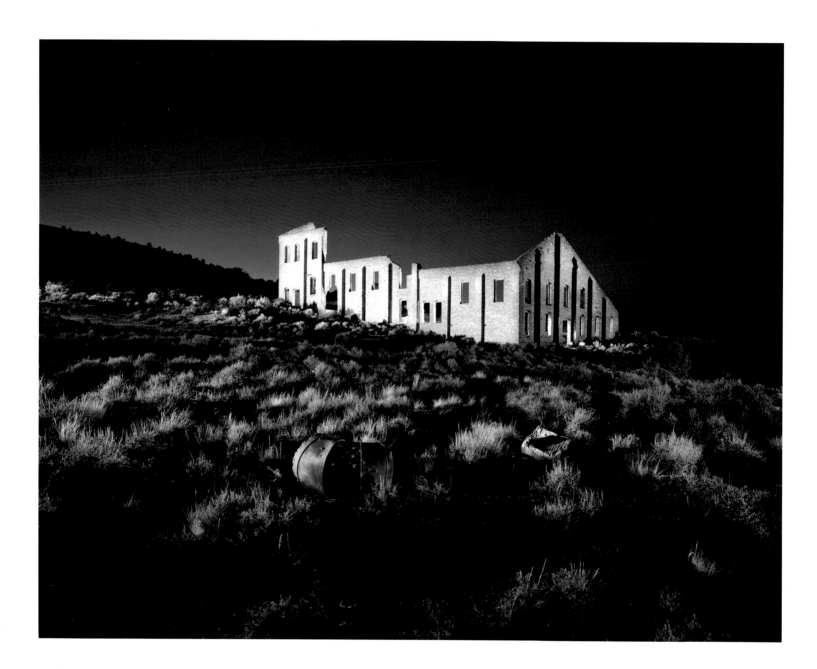

BELMONT, NEVADA

Cameron Mill. Indians found silver in the Toquima Mountains in 1865, and the town of Belmont was founded a few weeks later. Within a year more than four thousand people had already settled here. Belmont had thriving shops, saloons, and a post office, and its streets were lined with mining-company offices. But when new finds were made in the Gold Mountains, the town emptied out nearly as quickly as it had filled up. People left, taking their wooden houses with them, the mining machinery was hauled away, and the shops closed. Belmont would experience two revivals, one of them between 1915 and 1917, when new ore-processing plants like the Cameron Mill were erected. Once the mining companies had finally decamped, life in the town came to a standstill. By 1945 the town numbered only twenty-eight inhabitants. Even the discovery of uranium ore couldn't revive the place.

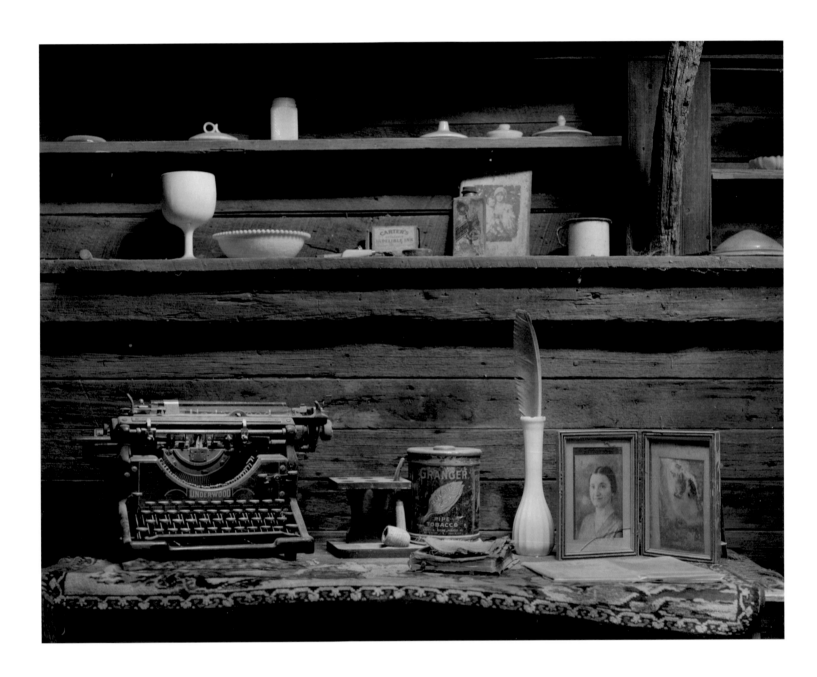

STEINS, NEW MEXICO

Still life with typewriter in Steins's largest dwelling. Steins was originally one of the main mail-coach stops in the Mexican border region. Then with the coming of the Southern Pacific Railway in 1880 the town began a period of modest prosperity, for it served as a stopover and refueling station for the steam locomotives. Solid houses replaced the earlier primitive shacks. Most had from two to four small, sparsely furnished, low-ceilinged rooms.

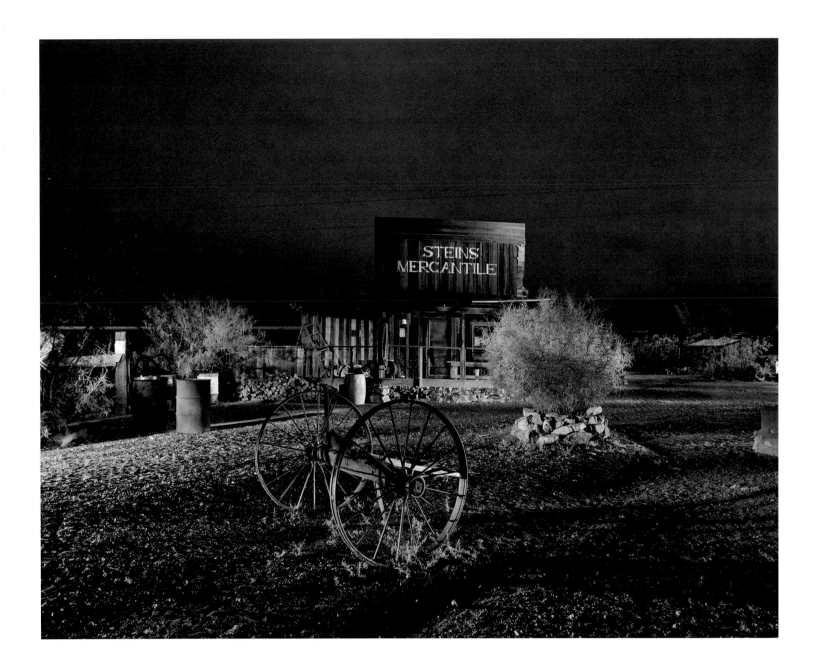

STEINS, NEW MEXICO

Steins Mercantile. The town was always a dangerous place. Apache warriors
were followed in the 1780s by bands of horse thieves and robbers. Any number
of notorious bandits found shelter in Steins, among them the legendary Black
Jack Ketchum. His last words before he was finally executed have given him
dubious fame: "For me it's no big thing to shoot somebody."

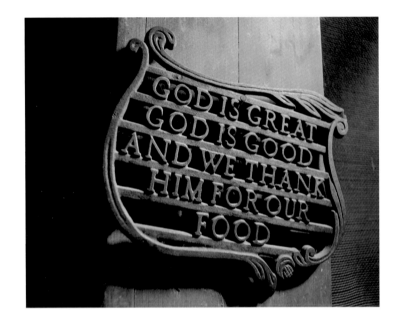 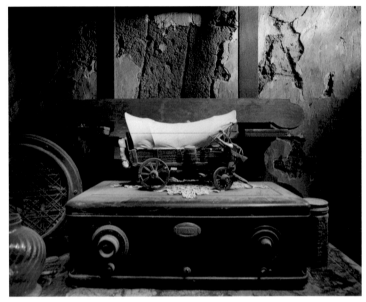

STEINS, NEW MEXICO

Kitchen sign. Model of a covered wagon in the largest of the houses still standing. In
the town's heyday, between 1905 and 1945, it numbered as many as one thousand
inhabitants. But when the Southern Pacific Railway switched from steam to diesel the
rail yard was closed and the place gradually declined.

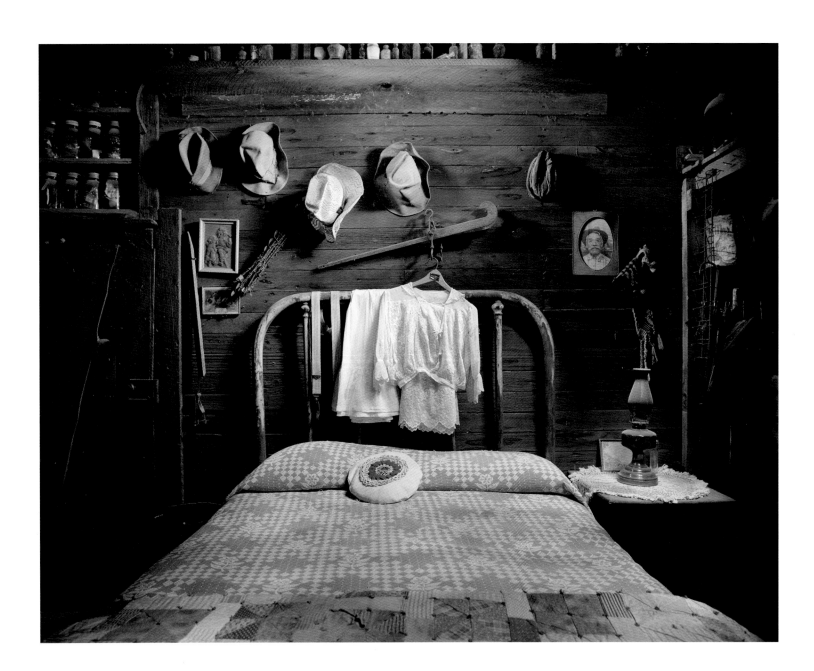

STEINS, NEW MEXICO

Bedroom in the largest surviving shack. People in Steins must have been tremendous collectors. Each room of every shack contains any number of objects that now belong to the town's history.

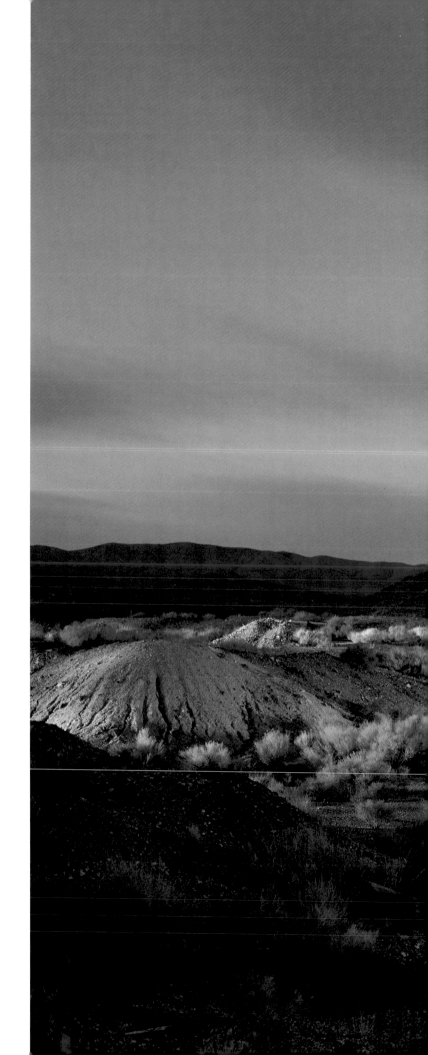

GOLD POINT, NEVADA

Winching tower of the Dunfee Mine. Silver was discovered in the Dunfee Mine already in the 1880s, though the miners had their hearts set on gold. A mining camp quickly sprang up and later the town of Gold Point. In 1960 the Dunfee Mine shut down, along with all of Gold Point's other mines. The search for silver was hampered by the fact that silver mixes easily with other minerals and can be difficult to recognize, and because there was no reliable field test for silver. At the time it was common to test the ore with nitric acid and hydrochloric acid, but samples had to be examined by experts to ensure the presence of silver. Once the silver content was established, it was necessary to determine the size of a deposit. Then there was an additional problem: silver was rarely found in surface veins that could be easily worked, and the ore had to be brought up from deep underground.

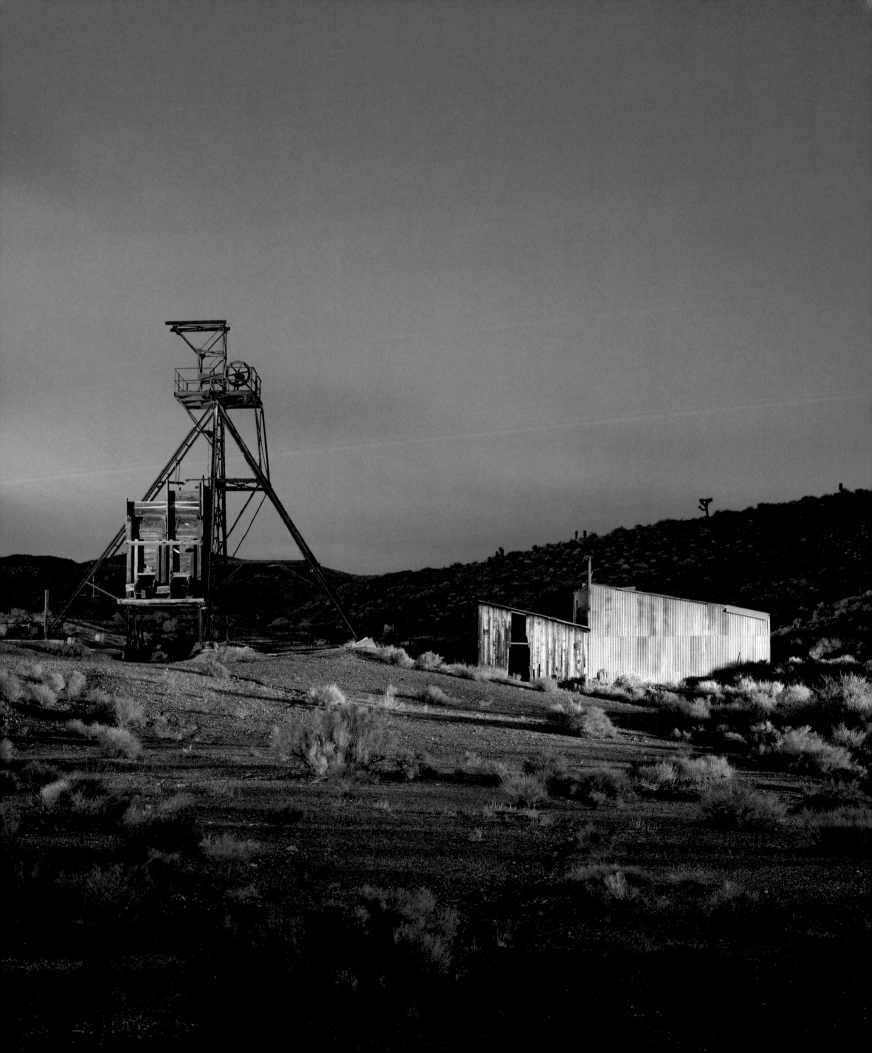

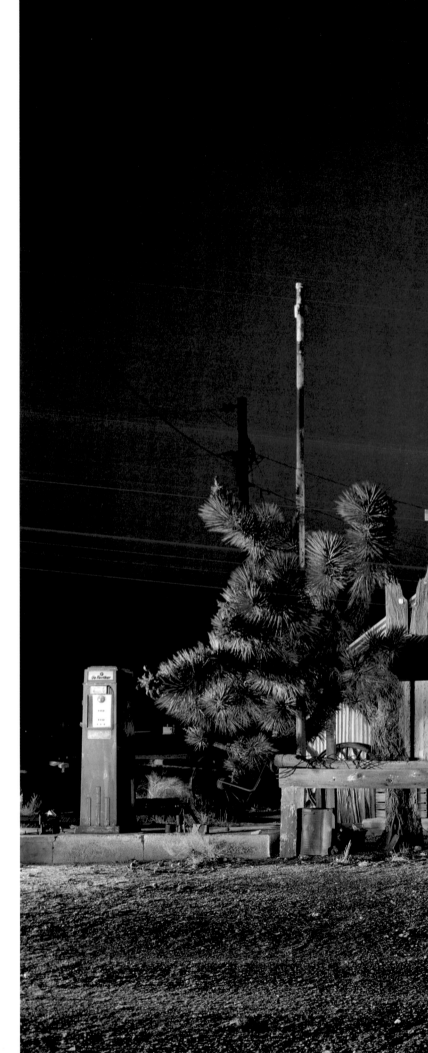

74

GOLD POINT, NEVADA

The post office and onetime store. Ora Mae Wiley was only passing through when she showed up in Gold Point in 1940, but here she met her husband, Harry, and ended up staying. Together they ran the small store and adjacent filling station and post office. When the mines closed in 1960, the town emptied out. Harry had died in 1955, but Ora Mae stayed on, living in the building next to the post office until her death in 1980.

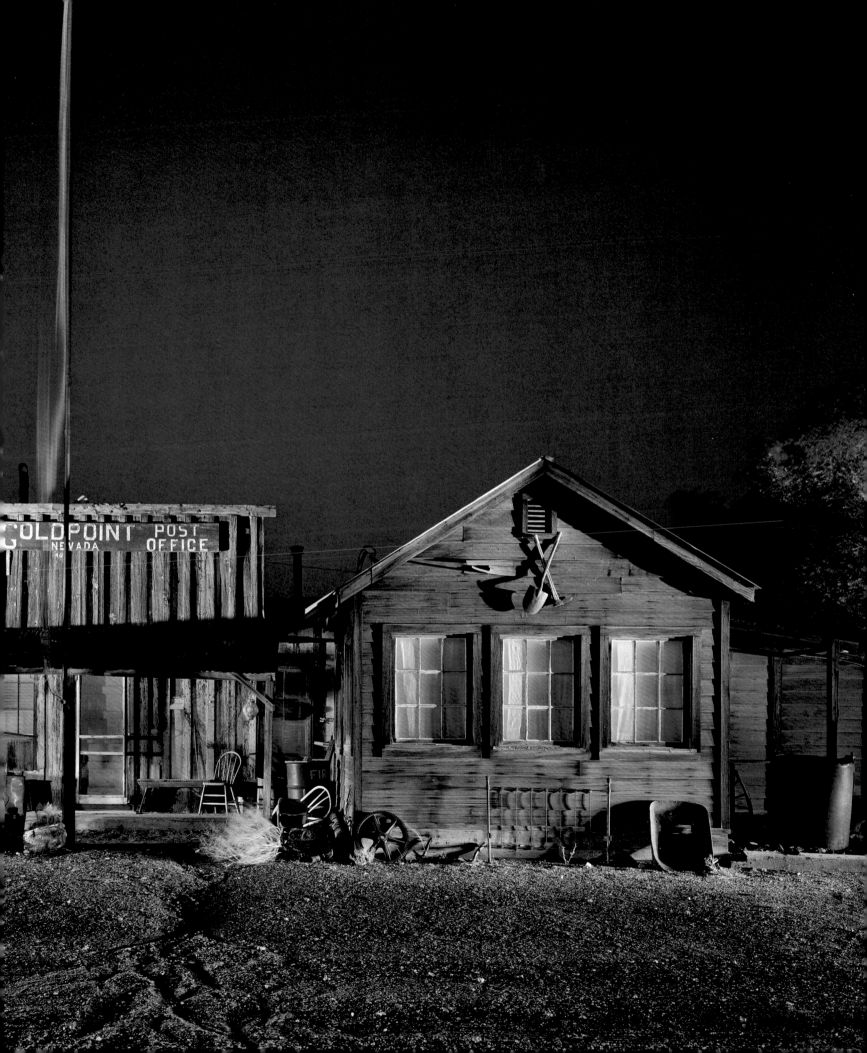

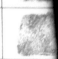

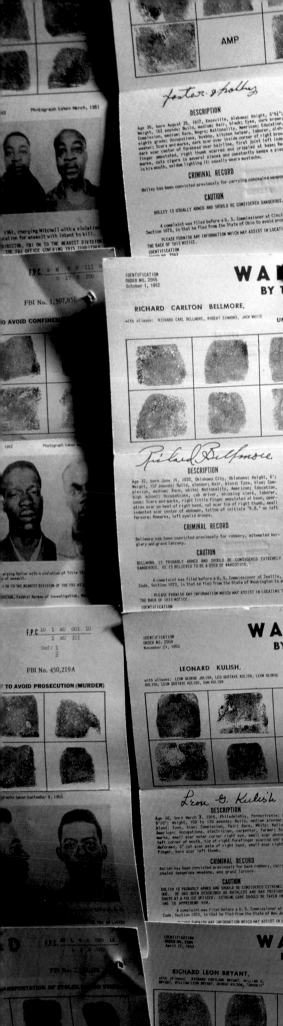
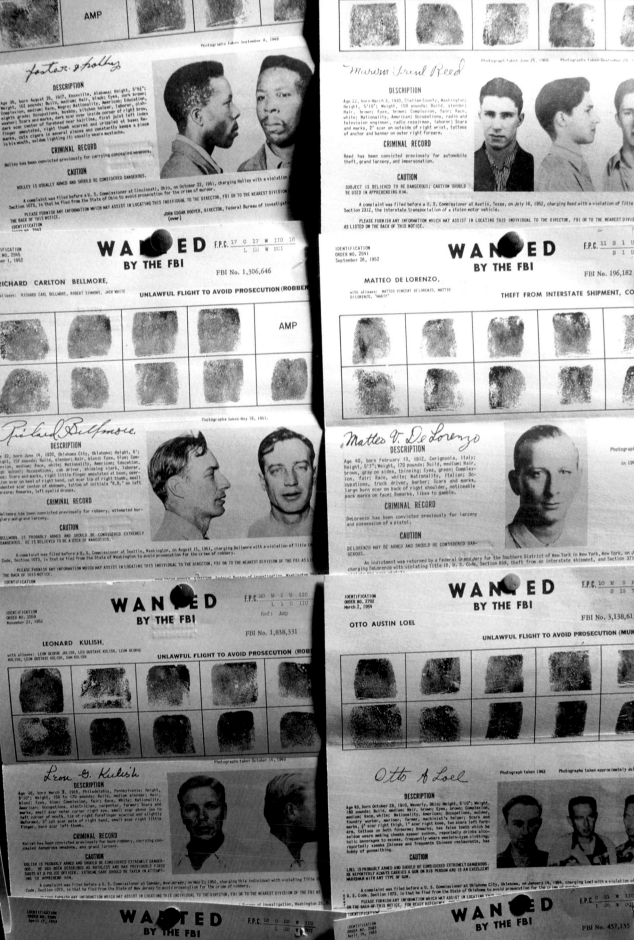

AMP

Photographs taken September 8, 1949

Foster J Holley

DESCRIPTION

Age 35, born August 26, 1917, Knoxville, Alabama; Height, 5'6½"; Weight, 162 pounds; Build, medium; Hair, black; Eyes, dark brown; Complexion, medium; Race, Negro; Nationality, American; Education, eighth grade; Occupations, busboy, kitchen helper, laborer, dishwasher; Scars and marks, dark scar over inside corner of right brow, dark scar center of forehead near hairline, first joint left index finger amputated, right thumb scarred and crippled at base; Remarks, cuts cigars in several pieces and constantly keeps a piece in his mouth, seldom lighting it; usually wears a mustache.

CRIMINAL RECORD

Holley has been convicted previously for carrying concealed weapons.

CAUTION

HOLLEY IS USUALLY ARMED AND SHOULD BE CONSIDERED DANGEROUS.

A complaint was filed before a U. S. Commissioner at Cincinnati, Ohio, on October 23, 1951, charging Holley with a violation of Section 1073, in that he fled from the State of Ohio to avoid prosecution for the crime of murder.

PLEASE FURNISH ANY INFORMATION WHICH MAY ASSIST IN LOCATING THIS NOTICE.

JOHN EDGAR HOOVER, DIRECTOR, Federal Bureau of Investigation

Marvin Irvin Reed

DESCRIPTION

Age 22, born March 3, 1930, Clallam County, Washington; Height, 5'10"; Weight, 150 pounds; Build, slender; Hair, brown; Eyes, brown; Complexion, fair; Race, white; Nationality, American; Occupations, radio and television engineer, radio repairman, laborer; Scars and marks, 2" scar on outside of right wrist, tattoos of anchor and banner on outer right forearm.

CRIMINAL RECORD

Reed has been convicted previously for automobile theft, grand larceny, and impersonation.

CAUTION

SUBJECT IS BELIEVED TO BE DANGEROUS; CAUTION SHOULD BE USED IN APPREHENDING HIM.

A complaint was filed before a U. S. Commissioner at Austin, Texas, on July 16, 1952, charging Reed with a violation of Title 18, U. S. Code, Section 2312, the interstate transportation of a stolen motor vehicle.

PLEASE FURNISH ANY INFORMATION WHICH MAY ASSIST IN LOCATING THIS INDIVIDUAL TO THE DIRECTOR, FBI OR TO THE NEAREST DIVISION OF THE FBI AS LISTED ON THE BACK OF THIS NOTICE.

IDENTIFICATION
ORDER NO. 2545
October 1, 1952

WANTED
BY THE FBI

F.P.C. 17 O 17 W IIO 16
 L 20 W IOI

RICHARD CARLTON BELLMORE,

with aliases: RICHARD CARL BELLMORE, ROBERT SIMONS, JACK WHITE

FBI No. 1,306,646

UNLAWFUL FLIGHT TO AVOID PROSECUTION (ROBBERY)

AMP

Richard Bellmore.

Photographs taken May 18, 1951.

DESCRIPTION

Age 32, born June 14, 1920, Oklahoma City, Oklahoma; Height, 6'; Weight, 157 pounds; Build, slender; Hair, blond; Eyes, blue; Complexion, medium; Race, white; Nationality, American; Education, high school; Occupations, cab driver, shipping clerk, laborer, cook; Scars and marks, right little finger amputated at base, operation scar on heel of right hand, cut scar tip of right thumb, small indented scar center of abdomen, tattoo of initials "R.B." on left forearm; Remarks, left eyelid droops.

CRIMINAL RECORD

Bellmore has been convicted previously for robbery, attempted burglary and grand larceny.

CAUTION

BELLMORE IS PROBABLY ARMED AND SHOULD BE CONSIDERED EXTREMELY DANGEROUS. HE IS BELIEVED TO BE A USER OF NARCOTICS.

A complaint was filed before a U. S. Commissioner at Seattle, Washington, on August 15, 1951, charging Bellmore with a violation of Title 18, Code, Section 1073, in that he fled from the State of Washington to avoid prosecution for the crime of robbery.

PLEASE FURNISH ANY INFORMATION WHICH MAY ASSIST IN LOCATING THIS INDIVIDUAL TO THE DIRECTOR, FBI OR TO THE NEAREST DIVISION OF THE FBI AS LISTED ON THE BACK OF THIS NOTICE.

IDENTIFICATION
ORDER NO. 2541
September 26, 1952

WANTED
BY THE FBI

F.P.C. 11 S 1 U IOI 6
 S 1 U III

MATTEO DE LORENZO,

with aliases: MATTEO VINCENT DELORENZO, MATTIO DILORENZO, "MARTY"

FBI No. 196,182

THEFT FROM INTERSTATE SHIPMENT, CONSPIRACY

Matteo V. DeLorenzo

Photograph taken in 1944

DESCRIPTION

Age 40, born February 13, 1912, Cerignola, Italy; Height, 5'7"; Weight, 170 pounds; Build, medium; Hair, brown, gray on sides, thinning; Eyes, green; Complexion, fair; Race, white; Nationality, Italian; Occupations, truck driver, barber; Scars and marks, large burn scar on back of right shoulder, noticeable pock marks on face; Remarks, likes to gamble.

CRIMINAL RECORD

DeLorenzo has been convicted previously for larceny and possession of a pistol.

CAUTION

DELORENZO MAY BE ARMED AND SHOULD BE CONSIDERED DANGEROUS.

An indictment was returned by a Federal Grand Jury for the Southern District of New York in New York, New York, on January charging DeLorenzo with violating Title 18, U. S. Code, Section 659, theft from an interstate shipment, and Section 371, conspiracy.

F.P.C. 10 1 aU OOI 10
 1 aU IOI

Ref: 1
 2

FBI No. 450,219A

... TO AVOID PROSECUTION (MURDER)

Photograph taken September 9, 1950

IDENTIFICATION
ORDER NO. 2569
November 21, 1952

WANTED
BY THE FBI

F.P.C. 20 M 1 U IIO
 L 1 U IIO

Ref: Amp

LEONARD KULISH,

with aliases: LEON GEORGE JULISH, LEO GUSTAVE KULISH, LEON GEORGE KULISH, LEON GUSTAVE KULISH, SAM KULISH

FBI No. 1,838,331

UNLAWFUL FLIGHT TO AVOID PROSECUTION (ROBBERY)

Leon G. Kulish

Photographs taken October 14, 1949

DESCRIPTION

Age 36, born March 3, 1916, Philadelphia, Pennsylvania; Height, 5'10"; Weight, 150 to 170 pounds; Build, medium slender; Hair, blond; Eyes, blue; Complexion, fair; Race, white; Nationality, American; Occupations, electrician, carpenter, farmer; Scars and marks, small scar outer corner right eye, small scar above jaw to left corner of mouth, tip of right forefinger scarred and slightly deformed, 3" cut scar sole of right hand, small scar right little finger, burn scar left thumb.

CRIMINAL RECORD

Kulish has been convicted previously for bank robbery, carrying concealed dangerous weapons, and grand larceny.

CAUTION

KULISH IS PROBABLY ARMED AND SHOULD BE CONSIDERED EXTREMELY DANGEROUS. HE HAS BEEN DESCRIBED AS RUTHLESS AND HAS PREVIOUSLY FIRED SHOTS AT A POLICE OFFICER. EXTREME CARE SHOULD BE TAKEN IN ATTEMPTING TO APPREHEND HIM.

A complaint was filed before a U. S. Commissioner at Camden, New Jersey, on May 2, 1952, charging this individual with violating Title Code, Section 1073, in that he fled from the State of New Jersey to avoid prosecution for the crime of robbery.

PLEASE FURNISH ANY INFORMATION WHICH MAY ASSIST IN LOCATING THIS INDIVIDUAL TO THE DIRECTOR, FBI OR TO THE NEAREST DIVISION OF THE FBI AS LISTED ... of Investigation, Washington

IDENTIFICATION
ORDER NO. 2702
March 2, 1954

WANTED
BY THE FBI

F.P.C. 10 M 9 R OOO
 S 18 U

OTTO AUSTIN LOEL

FBI No. 3,138,613

UNLAWFUL FLIGHT TO AVOID PROSECUTION (MURDER)

Otto A Loel

Photograph taken 1943 Photographs taken approximately July, 1953

DESCRIPTION

Age 43, born October 28, 1910, Waverly, Ohio; Height, 5'10"; Weight, 160 pounds; Build, medium; Hair, brown; Eyes, brown; Complexion, medium; Race, white; Nationality, American; Occupations, molder, foundry worker, mariner, farmer, machinist's helper; Scars and marks, 2" scar right thigh, 1" scar right knee, two scars left forearm, tattoos on both forearms; Remarks, has false teeth which he seldom wears making cheeks appear sunken, reportedly drinks alcoholic beverages to excess, frequently wears western-type clothing, reportedly speaks Chinese and frequents Chinese restaurants, has hobby of gunsmithing.

CAUTION

LOEL IS PROBABLY ARMED AND SHOULD BE CONSIDERED EXTREMELY DANGEROUS. HE REPORTEDLY ALWAYS CARRIES A GUN ON HIS PERSON AND IS AN EXCELLENT MARKSMAN WITH ANY TYPE OF GUN.

A complaint was filed before a U. S. Commissioner at Oklahoma City, Oklahoma, on January 14, 1954, charging Loel with a violation of Title U. S. Code, Section 1073, in that he fled from the State of Oklahoma to avoid prosecution for the crime of ...

PLEASE FURNISH ANY INFORMATION WHICH MAY ASSIST IN LOCATING ... ON THE BACK OF THIS NOTICE. FOR READY REFERENCE

F.P.C. O 81 W IIO 17

IDENTIFICATION
ORDER NO. 2594
April 21, 1953

WANTED
BY THE FBI

F.P.C. 18 O 28 W IIO
 L 152 W IOI

RICHARD LEON BRYANT,

with aliases: RICHARD CORTLAND BRYANT, WILLIAM C. BRYANT, WILLIAM LYON BRYANT, GEORGE WILSON, "BROOKIE"

FBI No. 750,008

UNLAWFUL FLIGHT TO AVOID CONFINEMENT (MURDER)

IDENTIFICATION
ORDER NO. 2588
April 14, 1953

WANTED
BY THE FBI

FBI No. 457,135

GEORGE LEONARD DA PRON,

with aliases: JAMES W. ALLEN, GEORGE LEONARD DA PRON, GEORGE LEONARD DE PRON, MIKE DA PRON, GEORGE LEONARD DA PRONE, GEORGE LEONARD DE PRONE, GEORGE LEONARD DA PROW, RAYMOND DE PRON, GEORGE LEONARD GARCIA, ... DENNIS J. SHIAN, GEORGE LEONARD ...

IMPERSONATION
INTERSTATE TRANSPORTATION OF STOLEN MOTOR V...

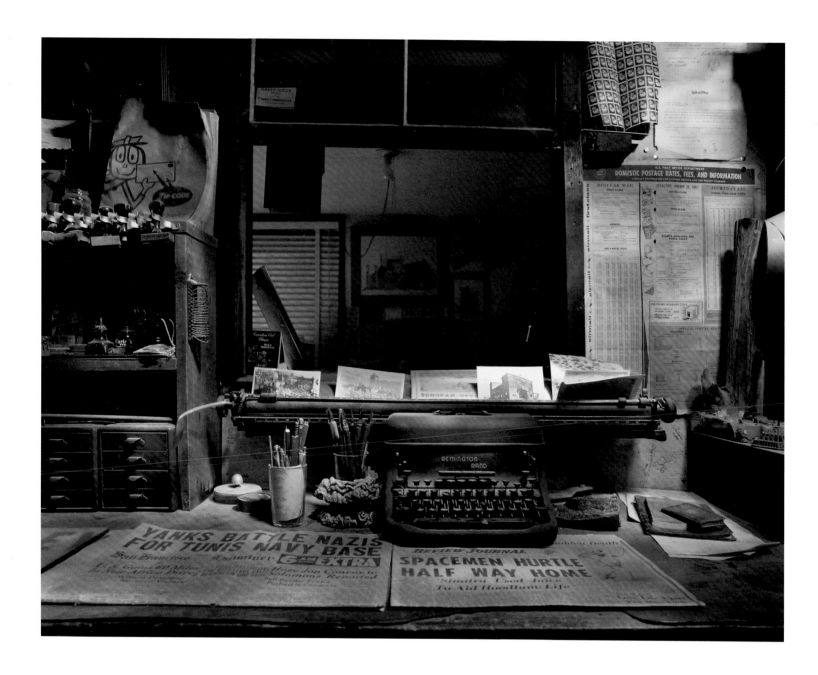

GOLD POINT, NEVADA (above)

Post office counter. Behind the window stands Ora Mae Wiley's old typewriter. Next to it lies a yellowed
copy of the *San Francisco Examiner*. Ora Mae ran the post office from 1940 until it closed in January 1968.

GOLD POINT, NEVADA (opposite)

FBI posters from the 1950s tacked up in the post office show the faces and fingerprints of weary criminals.
Gold Point, formerly called Hornsilver, expanded with lightning speed in 1908. Within a period of five
weeks it acquired two hundred houses, two hotels, and thirteen saloons, and a newspaper was started.
Its post office also dates from that time. The town never did have a church.

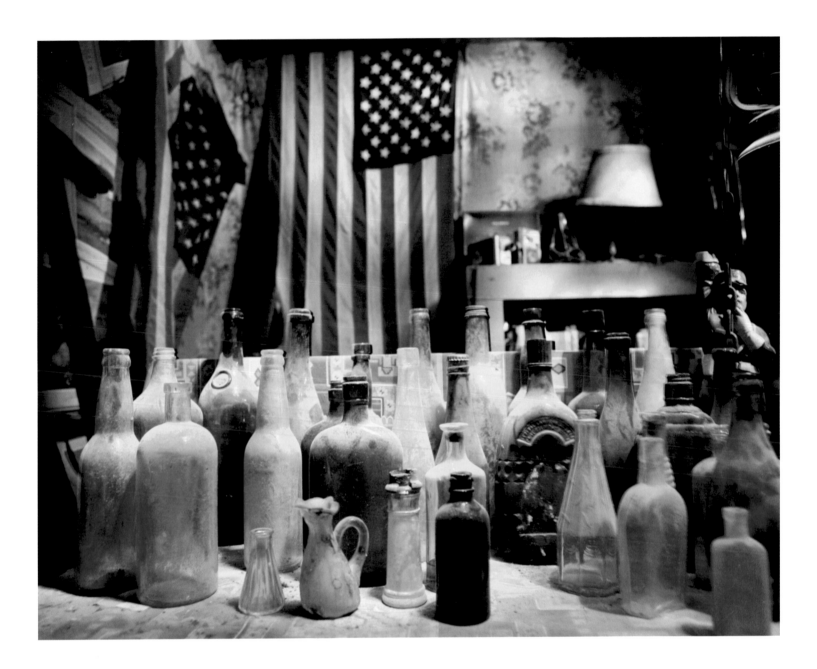

GOLD POINT, NEVADA (above)

Bottles and a flag collection in the store that stood next to the post office. Today there are still six people living in town: an elderly madam, a train engineer, a retired couple fond of peace and quiet, and Herb Robbins and the woman with whom he lives. With his move to Gold Point, Robbins realized a longtime dream. Now he works hard to preserve the ghost town's buildings.

GOLD POINT, NEVADA (opposite)

A small library in the former Gold Point store. Ora Mae Wiley set up the library for the town's older residents who no longer wanted to move from the deserted town.

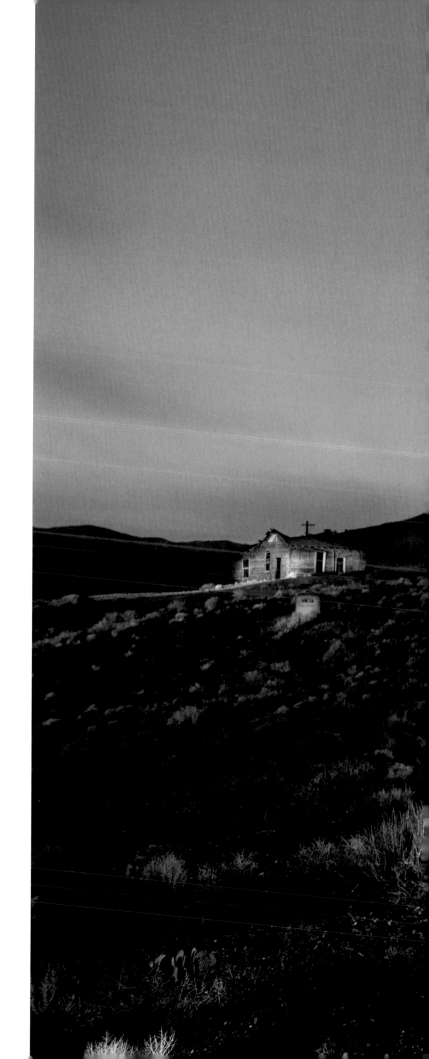

GOLD POINT, NEVADA

A Joshua tree and the Great Western Mine. The lives of early miners in the desert were full of privations: Water had to be brought in in barrels and small tanks, and the ore had to be transported more than twelve miles in mule-drawn carts for further processing. Only in 1927, when gold was first discovered, was the Great Western Mine finally mechanized. The ore was now crushed on the spot, then placed in a vat with mercury, water, salt, and copper sulfate. There were dozens of possible amalgamations, and every mine had its own secret recipe for leaching out the gold.

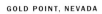

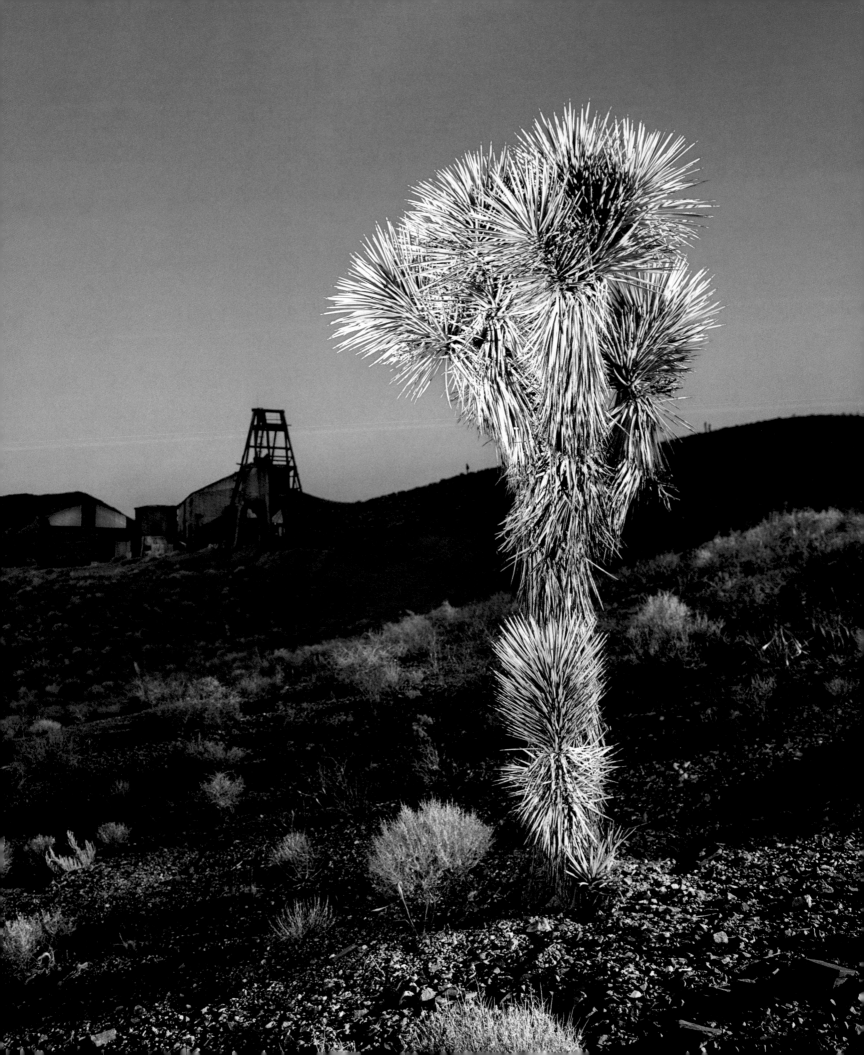

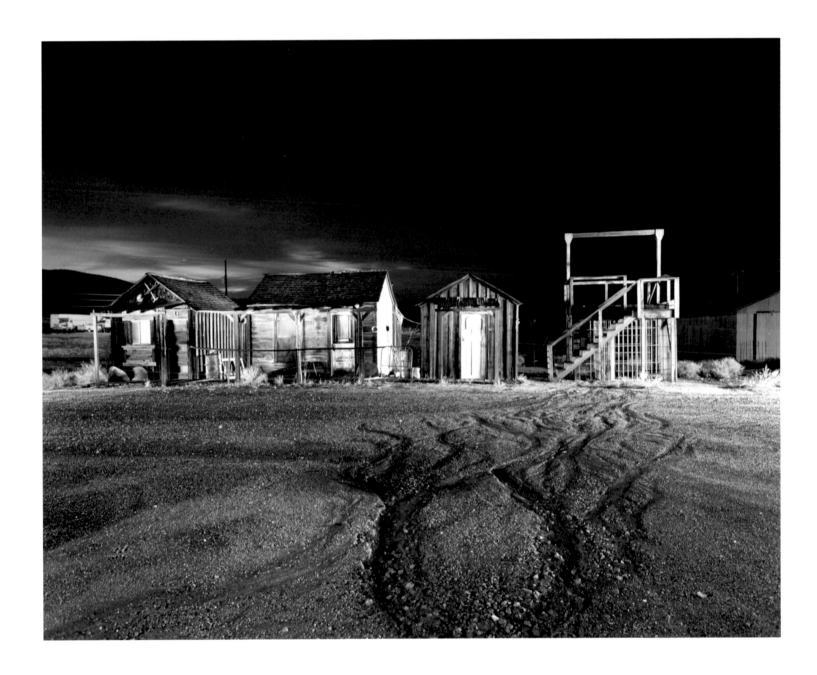

GOLD POINT, NEVADA

Workers' shacks were thrown up on Main Street in 1908, after rich deposits of silver were discovered. In 1927 J. W. Dunfee struck a large vein of gold in a nearby mine shaft. Because of its high price, more gold than silver was soon being mined, and on October 16, 1932, Hornsilver's residents renamed the town Gold Point.

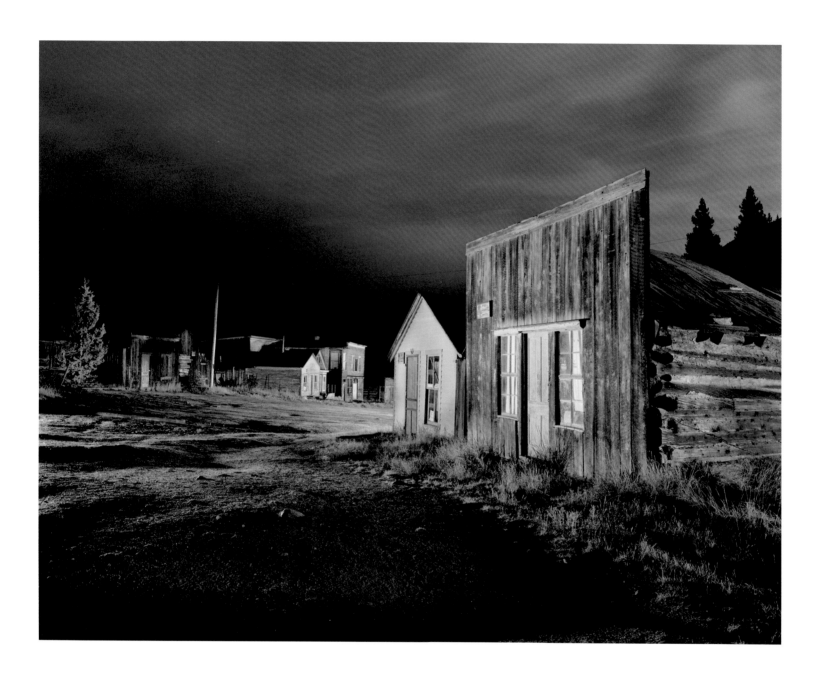

ST. ELMO, COLORADO

Main Street with buildings from the town's heyday around 1880–85. Rich veins of gold and silver
not only assured the town's survival, they saw to its prosperity. When prices for precious metals
eventually fell, the mines' output shrank significantly. Fewer and fewer passengers used the train
line to St. Elmo, and when the tracks were taken up in 1926, life in the town finally ceased to exist.

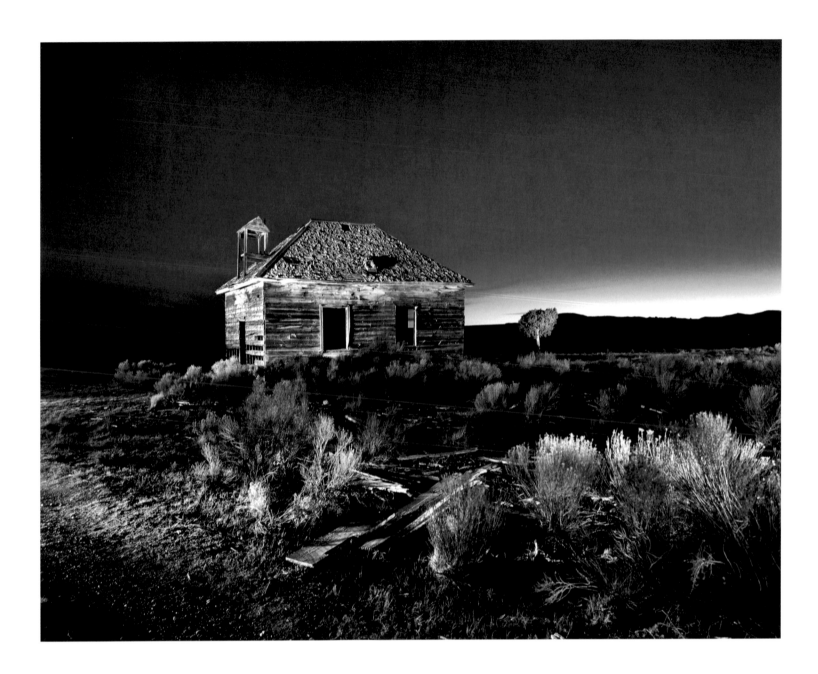

84

WIDTSOE JUNCTION, UTAH

The 1917 schoolhouse. The Mormons were the first settlers in the Bryce Canyon area.
In 1902 the Adair family developed a special system of dry farming, and thanks to it a
number of farmers were able to establish themselves in the arid region. In 1910 they
founded the town of Winder, which was renamed Widtsoe in 1917.

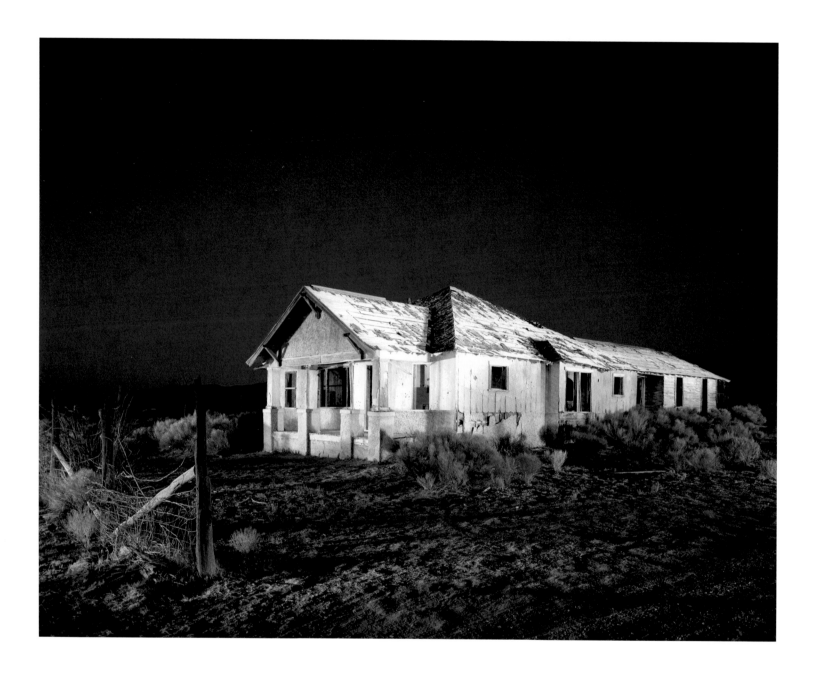

WIDTSOE JUNCTION, UTAH

The Woodard house. Extreme drought forced many families to abandon the
region in the 1930s. A federal emergency program helped to relocate them, and
Widtsoe became a showpiece of Western resettlement. The town's last inhabi-
tants left in 1938.

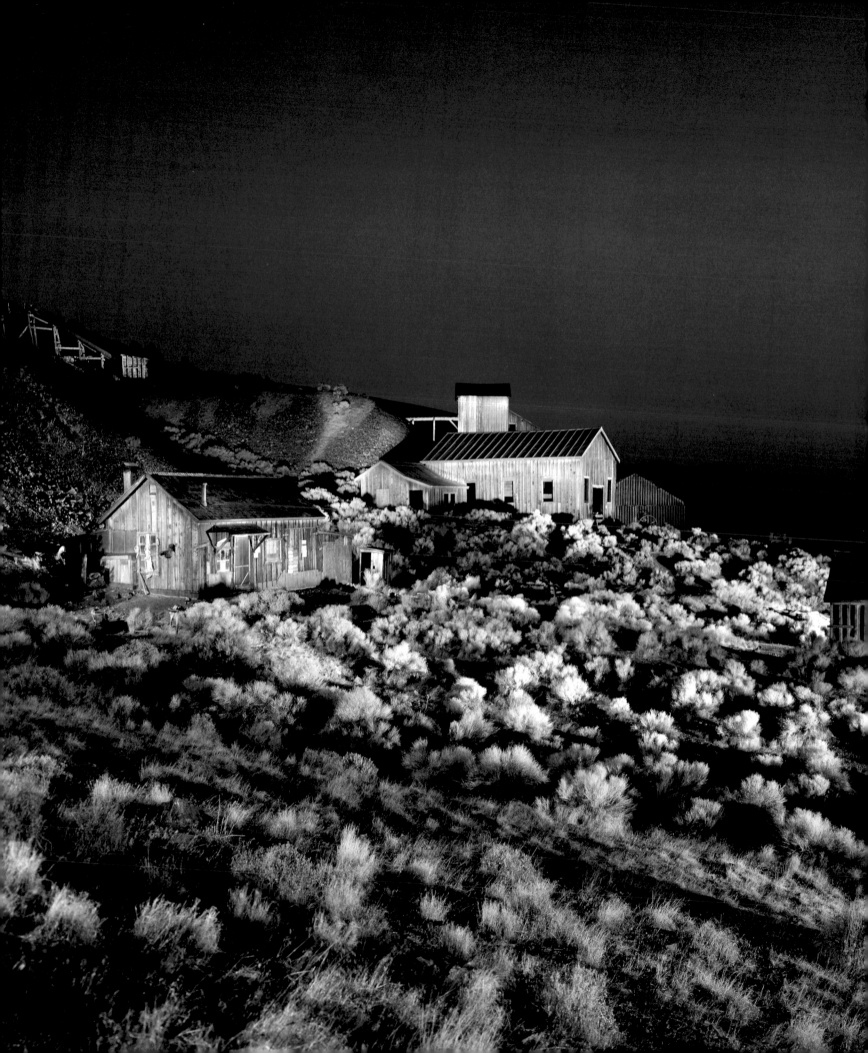

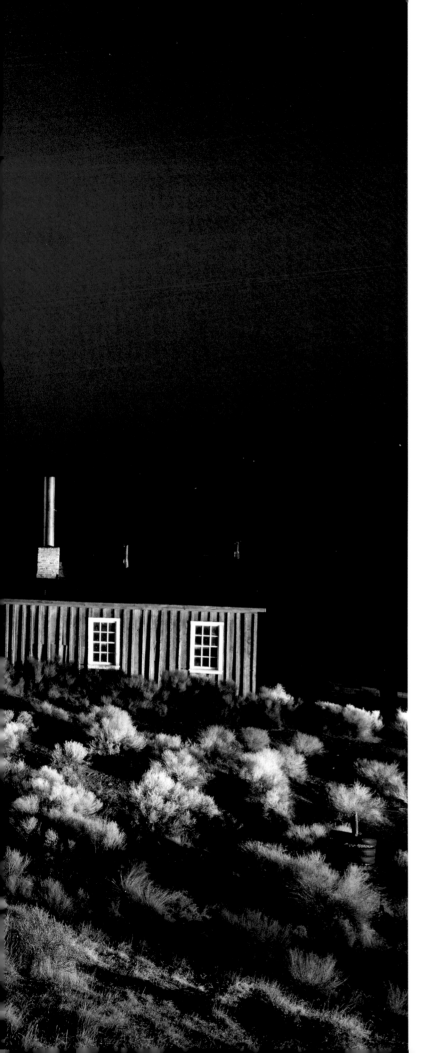

BERLIN, NEVADA

The last structures of this mining camp that became a ghost town in 1947. Next to the mail-coach stop and the machinery warehouse the buildings of the Berlin Mill, the ore-processing plant and assay office, survive in good condition. Berlin was founded in 1897 and never numbered more than three hundred inhabitants—most of them men. An 1850 census in California determined that women accounted for a mere eight percent of the state's population. In mining camps like Berlin the percentage was much lower than that.

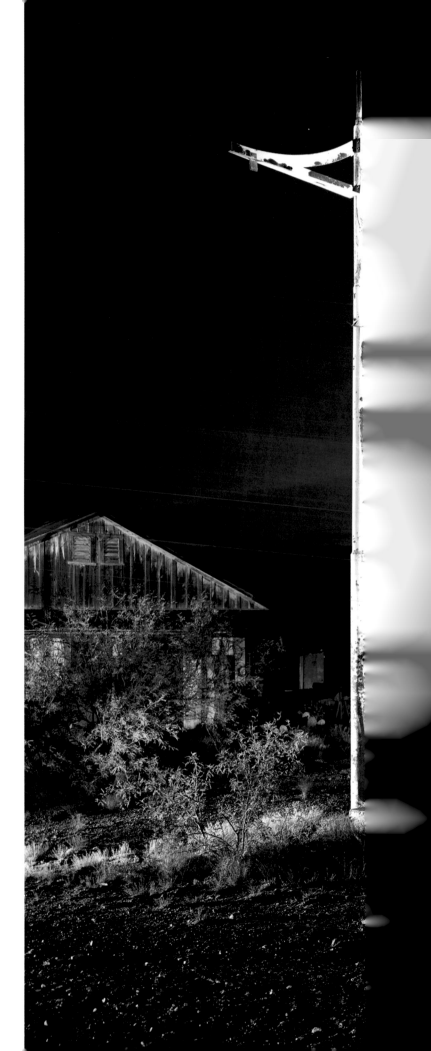

CORDES, ARIZONA

In the 1930s John Henry opened a filling station and adjacent store and restaurant next to the highway between Prescott and Phoenix. At that time it was the only one for miles around, and crucial to the area. The gas station and store burned down in 1938—it is said that it was on John Henry's wedding day. Everything was rebuilt, and a roadside motel was even added. A new Prescott-Phoenix highway built in 1960 bypassed Cordes by some twenty miles, and the gas station closed. Today the abandoned building stands next to a dusty track in the middle of a broad plain.

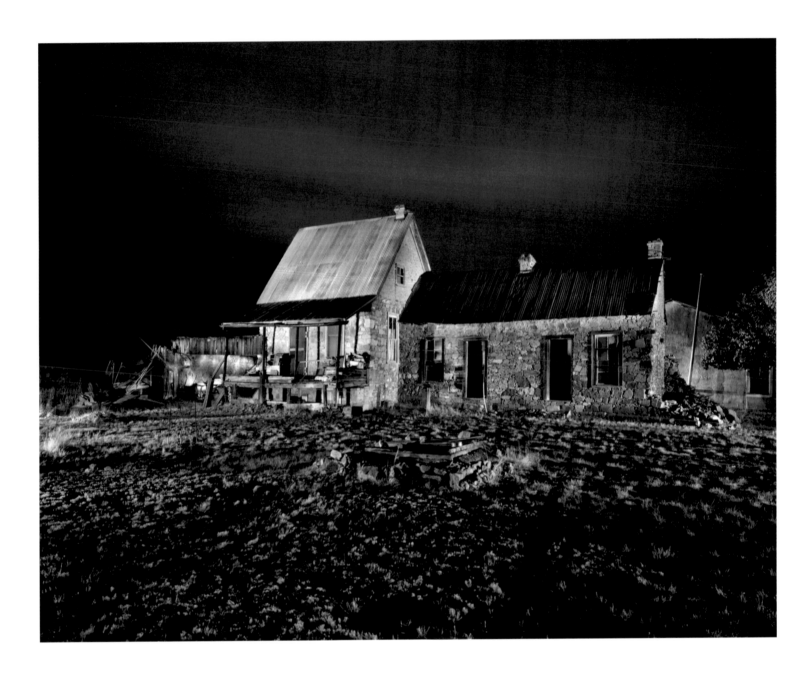

CHLORIDE, NEW MEXICO

Harry Pye discovered silver in a nearby canyon in 1879. A first tent city developed into the
town of Chloride. In its heyday, from about 1882–83, it numbered more than three thou-
sand inhabitants, but a fall in the price of silver brought on the town's rapid demise.

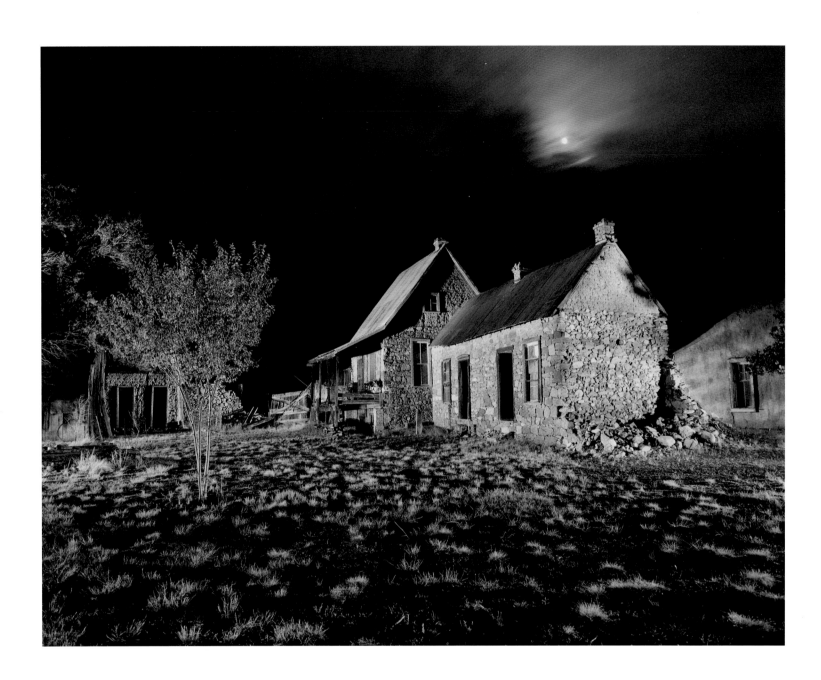

CHLORIDE, NEW MEXICO

In a dream, Austin Crawford saw the entire Chloride population killed by a
hailstorm, and the old man feverishly set about building this house with the
steep roof. The storm never came.

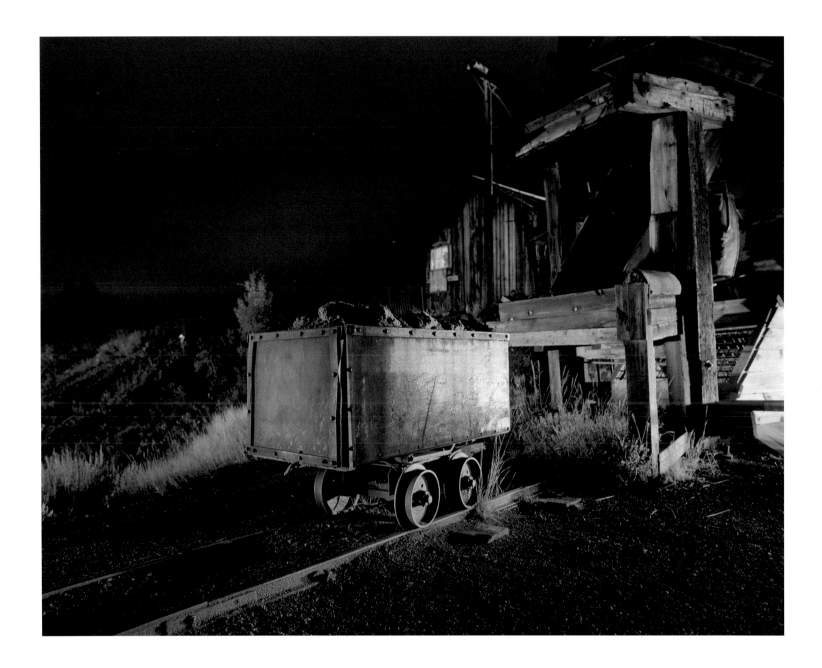

MATCHLESS MINE, COLORADO

Horace Tabor financed mining equipment for two German shoemakers, August Rische and
George Hook. The two subsequently made a rich strike, and Tabor received a one-third share. With
his earnings Tabor invested in other mines, and was soon one of the wealthiest and most respected
men in Leadville. When he met and fell in love with the young barmaid Elizabeth McCourt Doe,
called "Baby Doe," Tabor divorced his first wife—a scandal that raised eyebrows all across the coun-
try. In the great silver crash of 1893 Horace and Baby Doe lost virtually everything they owned,
except the Matchless Mine.

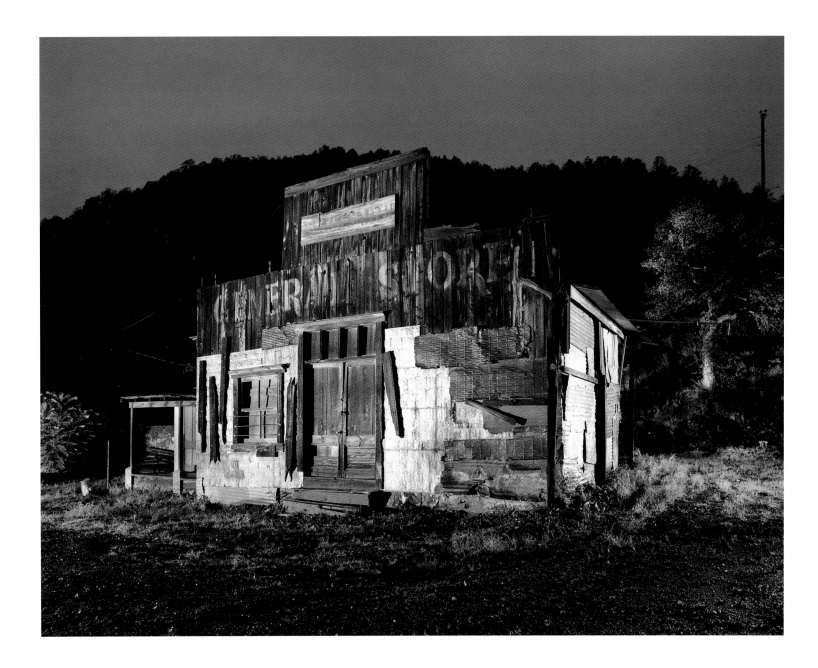

MOGOLLON, NEW MEXICO

A steep, narrow road leads down to Mogollon in Silver Creek Canyon. It was carved out of the rock by convicts in 1897. John Eberle first built a wooden shack in town and then in 1889 gold and silver mining began in the nearby mountains. Mogollon prospered to the point that it boasted a theater in addition to its saloons. By 1915 the town had a population of more than fifteen hundred.

The general store that stands on the town's main street is not as old—in 1973 it also served as a set in the Western *My Name Is Nobody*, starring Henry Fonda.

94

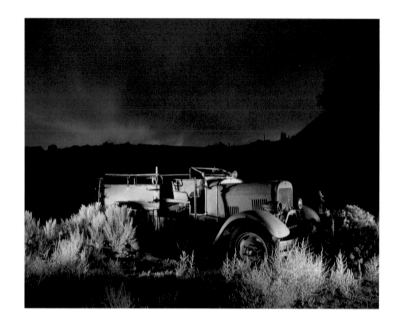 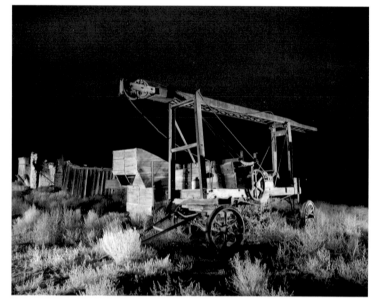

BELMONT, NEVADA

Relics from the past stand in a row along the town's only through street.

Belmont's fire engines stand next to the decaying ruins of former stores.

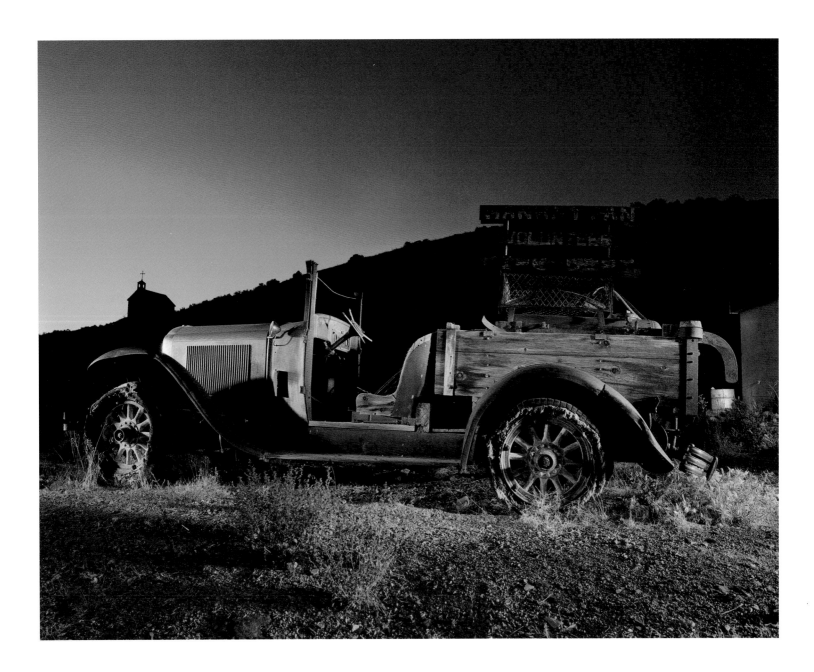

MANHATTAN, NEVADA

An old fire truck stands on the main street of this town, one of the early mining camps
on the slopes of the Bald Mountains. Despite two booms, one around 1860 and the
other in the early 1900s, the settlement sank into a deep sleep in 1905, and it continues
to this day. A few determined people still live here.

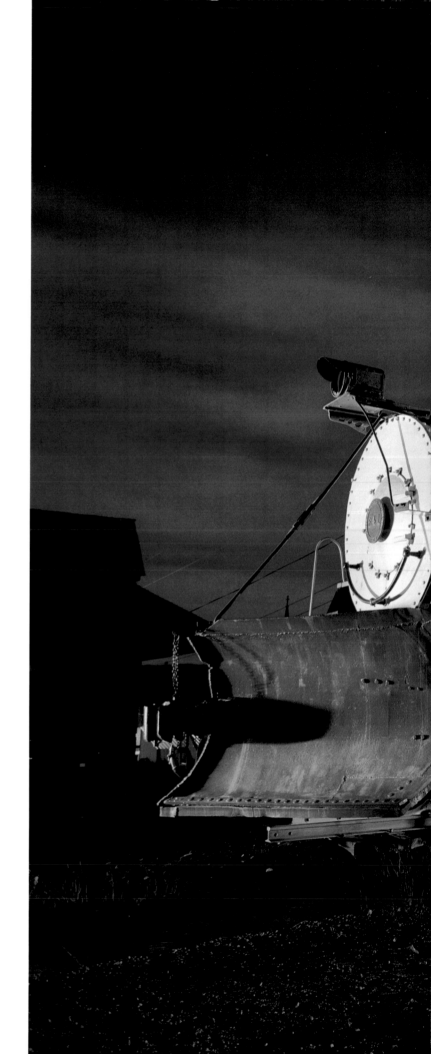

96

LEADVILLE, COLORADO

A 1906 class B-4-R locomotive of the Colorado & Southern Railway
stands next to the old Leadville depot.

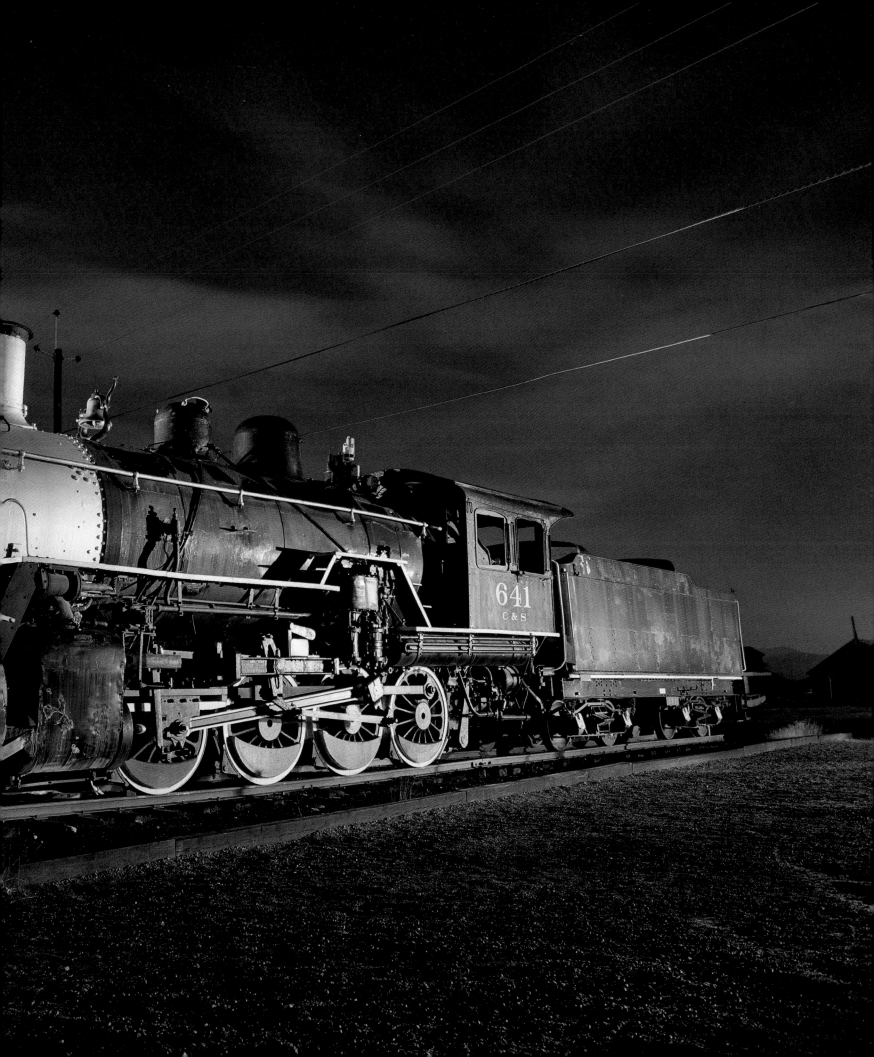

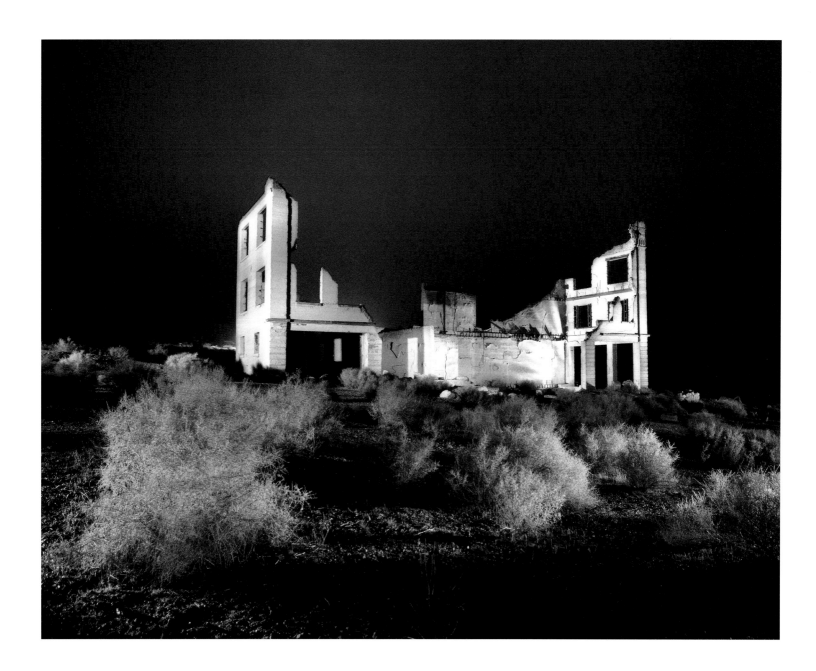

RHYOLITE, NEVADA

Cook Bank Building. In 1904 Frank "Shorty" Harris and Eddie Cross struck a rich vein of gold on the edge of Death Valley. In a drunken stupor one of them revealed its location, and within a matter of weeks their primitive camp had turned into the town of Rhyolite. Three years later it numbered more than ten thousand inhabitants. Solid concrete structures like the Cook Bank Building were erected. But once the deposits of ore were exhausted the exodus began. People packed up everything they owned, taking with them even their houses for the precious wood. The last Rhyolite resident died in 1924. Today only the concrete skeletons of the bank and the schoolhouse stand in the desert.

RHYOLITE, NEVADA

The Cook Bank was the tallest building in Rhyolite. An elegant vault spanned the lobby, and the marble for the floor was specially imported from Italy. The counters were made of the finest mahogany. Tellers had their own telephones, and the building boasted electric light and running water. The bank was a fully modern structure surrounded by wooden shacks.

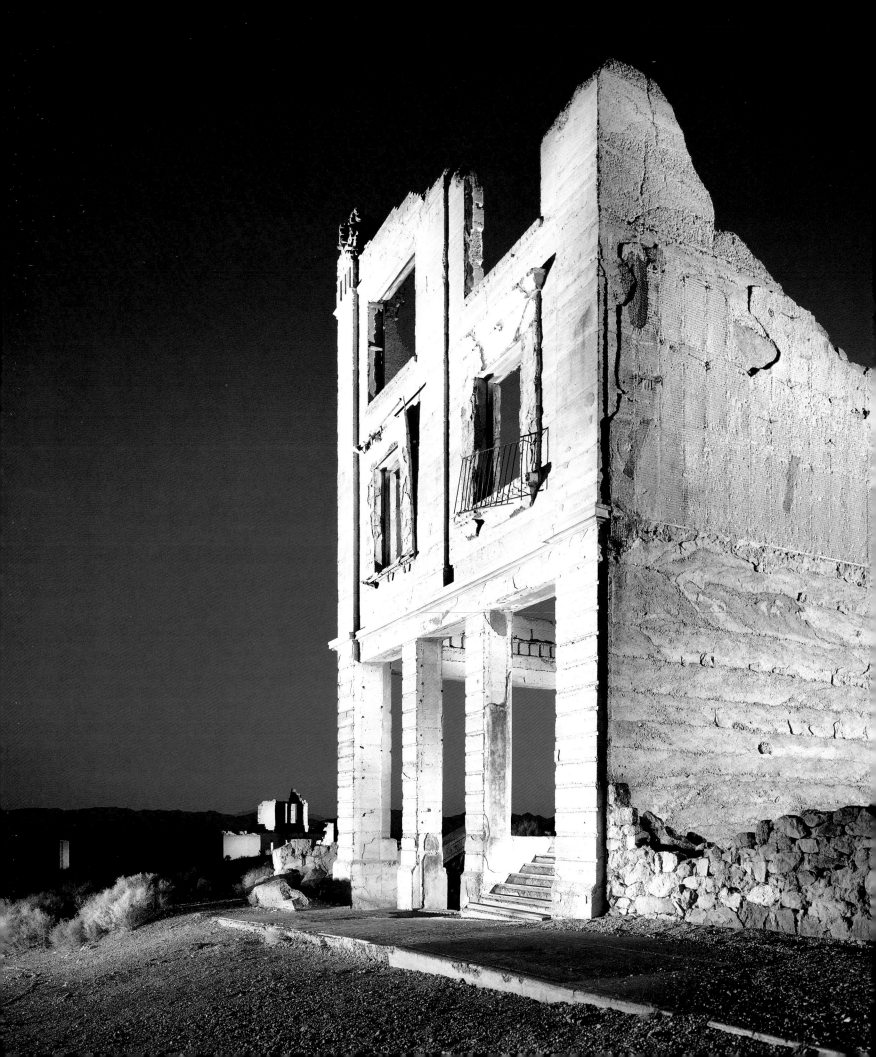

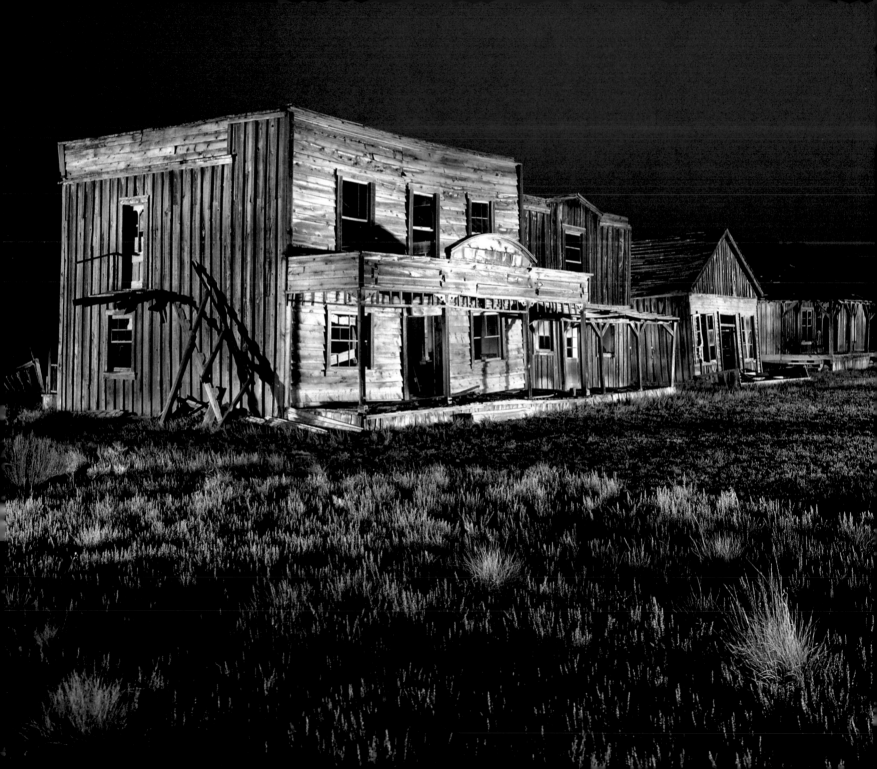

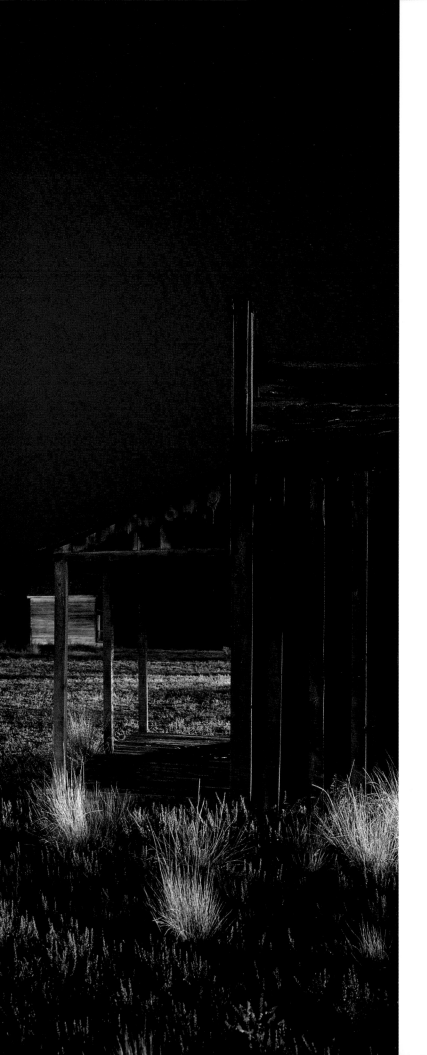

JOHNSON, UTAH

In the early 1950s the buildings of the abandoned town of Johnson were turned into a film set. A number of Westerns were filmed here, as well as the TV series *Gunsmoke*. The centerpiece of the series was Miss Kitty's Longbranch Saloon (far left).

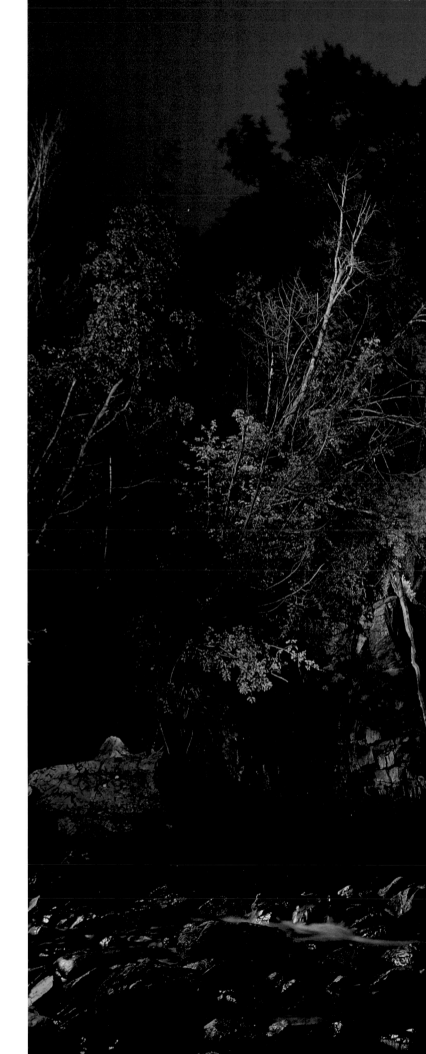

CRYSTAL, COLORADO

The first miners in the Rocky Mountains showed up in Crystal in 1860, but it would be another twenty years until a road was built on which horse-drawn wagons could bring the necessary mining machinery up into the mountains. During its boom years some five hundred people lived in Crystal. It had a hotel, a post office, a billiard salon, and two newspapers, the *Crystal River Current* and the *Silver Lance*.

PAINTING WITH LIGHT: THE PHOTOGRAPHY OF BERTHOLD STEINHILBER

BERTHOLD STEINHILBER TAKES HIS MEDIUM LITERALLY. He paints with light, and in doing so leads photography back to its roots. The pioneers of this technological photographic medium had the quaint notion that the sun "drew" pictures on a surface provided by the "operator." This surface could be either a copper plate covered with a film of silver, as in the daguerreotype, or light-sensitive paper, as in the calotype. Accordingly, they spoke of sun pictures, light prints, photogenic drawings. That is until around 1839, when the polymath John Frederick William Herschel came up with the word "photography," which simply means "writing with light." What's different about Steinhilber's work is that the sun no longer does the writing. Instead, the photographer himself directs the process, which requires a large-format camera, a solid tripod, proper film, good weather through the period between dusk and nightfall known as twilight, a portable spotlight, a great deal of patience, and above all, a mental image he wishes to translate into a picture.

Have I just revealed a secret? Perhaps. But even after one learns how he creates them, Steinhilber's pictures retain the amazing aura that critic Walter Benjamin claimed was lacking in photography. But in an era when "straight photography" was clamoring loudly for recognition, it is possible that Benjamin was too mired in the notion that photography was merely a reproducing art. Steinhilber skirts the terrain of the documentary, instead favoring his highly idiosyncratic images. What he creates with his subtle manipulation of light we will never experience in reality, yet his images are inextricably linked to the physical world. His tableaux are inventions in the truest sense. His creations enrich our visual cosmos, lend wings to our thinking, and fire our imagination. In this respect Steinhilber is an artist, one who—wholly in tune with postmodern media practice—has set out to generate pictures that are indebted to the technological medium but are not limited by conventional photography's disdain for any kind of staging or manipulation.

Paradoxical though it might seem, Steinhilber creates virtual images with an analog camera.

Steinhilber was born in Tübingen, Germany, in 1968. After high school he underwent classical training in photography, for a time in the Rubold advertising studio. There he picked up some important techniques, especially how to handle light. In 1993 he began studying photography under Professor Harald Mante in Dortmund. Major reporting assignments took him to Slovenia and Romania—but even before he began his study he had been to Timbuktu, in West Africa, as a photographer. Steinhilber is still inspired by the ideal of classical photojournalism. Yet if one asks him who his role models were at that time, he will assure you that they were not the sainted apostles of the "decisive moment," chief among them Henri Cartier-Bresson, to whom more than one generation of photographers has paid homage. Steinhilber felt particularly drawn to Eugène Atget, that Parisian loner from the end of the nineteenth century whose mostly unpopulated cityscapes Benjamin described as "crime scenes." In other words, they were places where things had happened—which could certainly be said of Steinhilber's ghost towns as well.

Early on, and without following any specific doctrine, Steinhilber developed his own way of leading the eye, one that might preserve history in a subtle, offbeat way. He wished to avoid everything anecdotal, mere narrative. Steinhilber's pictures are meant to be studied, read, deciphered, calling for more than a passing glance. They are refreshingly unmodern, and stand apart from the stream of visual data we are fed by television, video, and the Internet. They are, to use the words of media scholar Norbert Bolz, "large, quiet pictures"—pictures that underscore the power and visual intensity of analog picture taking.

From 1996–97 Steinhilber studied at a small photography school in Falmouth, England. He wanted to focus on a concept for a lighting technique he had been hatching for some time. He had begun experimenting with the technique as a student in Dortmund in the mid-1990s, in a series on southern German bedrooms that first brought him attention in connection with a German photography prize. There Steinhilber had photographed simple bedrooms, almost always looking straight toward the wall behind the bed. His photographs reveal pictures of saints, biblical scenes in baroque frames, floral print wallpapers, bedside lamps. The atmosphere is serene; there are no people visible, though the beds are carefully made. Here for the first time we encounter Steinhilber's deserted "crime scenes," dark rooms illuminated by only a simple flashlight.

In England he wanted to take his new technique outdoors to photograph monastery ruins. He still used the large camera and the long exposure time, stretching anywhere from forty minutes to four hours. He also kept the directed light, illuminating twilight as though with a brush. Instead of flashlights he now used a large converted ship spotlight powered by a car battery, aiming its concentrated beam at the windows, portals, cornices, columns, and edges of broken walls of medieval churches in various states of ruin. With his "light brush" and battery he would walk around a struc-

ture, the camera shutter open all the while. What to reveal was literally in his hands. Anything his beam of light did not strike would remain invisible, or at most only background. Steinhilber invents pictures—not by constructing, moving, or combining anything, but rather by simply exposing what is there.

David Mathews, one of Steinhilber's teachers in Falmouth, was impressed by the young German's work. So was *Smithsonian Magazine*, in whose pages international readers first saw his English monasteries. Reader response was so positive that the editors asked Steinhilber for a series of photographs created specially for them. It was to have an American subject, but make use of the lighting technique that had so impressed their readers. They suggested Civil War battlefields, but Steinhilber was not interested. He felt that his artistic approach was inappropriate in places where unambiguous messages linger. He would not even want to interpret modern war ruins in this way. He finally settled on ghost towns of the American Southwest, those settlements thrown up so quickly during the Gold Rush and just as quickly abandoned. To him they stand as embodiments of the American dream: the chase after instant wealth even if it means the place you call home is one day here and the next day someplace else.

Steinhilber hit the road. He traveled for some six weeks, armed with his large-format Silvestri camera, a Mamyja 6 x 7, plenty of film both for slides and color negatives, his converted spotlight, and a brushed-up knowledge of American history. He roamed between California, Nevada, Utah, Colorado, New Mexico, and Arizona. He would prowl around a location during the day, then in the early evening, against a deep blue sky, create the pictures that had already taken shape in his mind. He rarely needed a second try. Steinhilber is a professional and fully at home in his craft. He does admit that illuminating trees is very difficult, "because they don't reflect well. For them you sometimes need to triple the exposure time." He left everything just as he found it, even the interiors, which look as though their inhabitants fled on a moment's notice. Steinhilber is content with things as he finds them. What intrigues him is the business of using his technique to let the scenes speak for themselves. He sees himself as a storyteller. Not of "ghost stories," though any number of people writing about his pictures of ghost towns have felt that to be a clever thing to say. Steinhilber's stories are more complex, and oddly ambiguous. They take place on the boundary between day and night, life and death, reality and artificiality. The Romantics reveled in what they called "night pieces." In both literature and art these represented the very antithesis of the Enlightenment's desire to shed light everywhere. Night pieces explored the shadowy corners beyond the reach of reason—moods, emotions, premonitions, dreams. Steinhilber also searches out the vague and ambiguous, hoping to give our imaginations a kind of jump start, something perhaps necessary in this era of digital intelligence. His subjects are altogether real, but they seem like stage sets: deserted, empty, waiting for the start of the play that we—their viewers—concoct in our own minds.

HANS-MICHAEL KOETZLE

CONTENTS

ACKNOWLEDGMENTS

Most of the ghost towns I photographed are privately owned. My thanks to all their owners for permitting me to visit them and for granting me the time I needed.

I would especially like to thank Rebecca Scott and Julia Hayen and their associates of Bodie State Park, Herb Robbins (Gold Point), Chris Connell (St. Elmo), Don and Dona Edmund and Van (Chloride), Patsy McDonald (Cordes), Chris Bramwell (Belmont), Larry and Linda Link (Steins), J.A. Caldwell (Massicks), Trevor Stewart (Johnson), and Hank and Pat Kimbrell at Beaver Lake Lodge (Crystal).

I am especially grateful to Edgar Rich at *Smithsonian Magazine* in Washington. It is thanks to his interest and support that I was able to produce these photographs.

My thanks to Brigitte Schneider for her patience and endurance during a trip that took us through the rain-soaked mountains of Colorado and the wasteland of Nevada under the most unfavorable conditions.

PROJECT MANAGER, ENGLISH-LANGUAGE EDITION: Susan Richmond

EDITOR, ENGLISH-LANGUAGE EDITION: Libby Hruska

JACKET DESIGN, ENGLISH-LANGUAGE EDITION: Michael Walsh and Brankica Kovrlija

DESIGN COORDINATOR, ENGLISH-LANGUAGE EDITION: Tina Thompson

LIBRARY OF CONGRESS CATALOGING-IN-PUBLICATION DATA

Steinhilber, Berthold.
 [Geisterstèadte in Amerikas Westen. English]
 Ghost towns of the American West / photographs by Berthold Steinhilber
; foreword by Wim Wenders ; introduction by Mario Kaiser ; afterword by
Hans-Michael Koetzle ; translated from the German by Russell Stockman.
 p. cm.
Includes index.
 ISBN 0-8109-4508-8 (hardcover)
 1. Ghost towns—West (U.S.)—Pictorial works. 2. West
(U.S.)—History, Local—Pictorial works. I. Title.

F590.7.S74 2003
779'.9978—dc21

 2002155256

PRINTED AND BOUND IN GERMANY
10 9 8 7 6 5 4 3 2 1

Harry N. Abrams, Inc.
100 Fifth Avenue
New York, N.Y. 10011
www.abramsbooks.com

Abrams is a subsidiary of